A Garland Series

OUTSTANDING
DISSERTATIONS
IN THE

FINE
ARTS

Aspects of "Official" Painting and Philosophic Art 1789–1799

Diane Kelder

Garland Publishing, Inc., New York & London

1976

Library of Congress Cataloging in Publication Data

Kelder, Diane.
 Aspects of "official" painting and philosophic art,
1789-1799.

 (Outstanding dissertations in the fine arts)
 Originally presented as the author's thesis, Bryn
Mawr, 1966.
 Bibliography: p.
 1. Neoclassicism (Art)--France. 2. Painting, Modern
--17th-18th centuries--France. 3. France--History--
Revolution, 1789-1799--Art. 4. History in art.
5. Art--Philosophy. I. Title. II. Series.
ND546.5.N4K44 759.4 75-23797
ISBN 0-8240-1992-X

Printed in the United States of America

ASPECTS OF 'OFFICIAL' PAINTING AND PHILOSOPHIC

ART 1789-1799

by

Diane M. Kelder

April 10, 1966

Submitted to the Faculty of Bryn Mawr
College in partial fulfillment of the
requirements for the degree of Doctor
of Philosophy.

Author's Note

Although I have made no changes or additions
to this dissertation, I wish to call the reader's
attention to some significant books and articles
published since it was written.

Carlson, Marvin. The Theater of the French
Revolution, Cornell University, 1967

Ettlinger, Leopold. "Jacques Louis David
and Roman Virtue," Journal of the Royal
Society of the Arts, 115, January, 1967,
pp. 105 - 123

Herbert, Robert. David: Brutus (Art in Context)
New York: Viking, 1973

Rosenblum, Robert. Transformations in Late
Eighteenth Century Art, Princeton: Princeton
University Press, 1967

Sloane, Joseph C. "David, Robespierre and
the Death of Bara'," Gazette des Beaux Arts, 6, 74,
September, 1969, pp. 143-152

TABLE OF CONTENTS

Acknowledgements

I would like to thank the many individuals and
institutions who assisted me in writing this disserta-
tion. Professor Joseph C. Sloane provided the initial
encouragement through his criticisms of a seminar report
given in the Spring of 1958 and also allowed me to
examine his notes on the Panthéon and on the survival of
the revolutionary spirit in Nineteenth century philoso-
phy. Professor Charles Mitchell generously gave time
and numerous suggestions for the improvement of the out-
line and chapters sent to him. Professor Anne Hanson
has given most valuable criticism of the entire work and
has suggested a number of editorial changes. In addition,
she has provided needed moral encouragement.

In France, kind assistance was given me in the
Cabinet des Estampes of the Bibliothèque Nationale, by
the direction of the Musée Carnavalet (Museum of the City
of Paris) and at the Louvre. In this country, the librar-
ies of the Metropolitan Museum, the Institute of Fine
Arts of New York University and of Bryn Mawr College were

especially helpful as was the University of Chicago Library which provided material through Interlibrary Loan Service.

I wish to reserve my special thanks and appreciation for the American Association of University Women who awarded me the May Treat Morrison Fellowship in 1962. This fellowship enabled me to complete my major research in Paris.

Finally, I express deepest thanks to the faculty of the department of History of Art for having generously provided funds for my first trip to France in 1959 and for having awarded a grant which made the securing of photographs and other research aids possible.

INTRODUCTION

During the second half of the eighteenth century
the exponents of neoclassicism enthusiastically spread
their printed and painted manifestos throughout England
and the continent. Yet nowhere was the neoclassic
style so committed to a political and philosophical
program as in France where the men of 1789 called on it to
express pictorially the essence of the great Revolution.
Considerable energy had been spent by the <u>philosophes</u>
in their search for an ultimate solution to the prob-
lems of mankind--a search for permanence which had
developed as a reaction to the decaying fabric of con-
temporary European society. While men of the Renais-
sance had invoked the classical past because they felt
they shared a bond of greatness with that past, the
theorizers of the eighteenth century generally looked
to the art and institutions of Greece and Rome as a
source for the stability and grandeur their own culture
seemed to lack.

The Revolution was viewed by its partisans as

the instrument through which a final and perfect solu-
tion to age-old problems would be found. It was
regarded as both a potential moral force and as a
social and political force which would engender further
change. It was conceived therefore as a Reformation
which would put an end to inequality and intolerance
and transform men into the virtuous citizens of a
virtuous state. Where religious orthodoxy had taught
the inherent sinfulness of mankind and his constant
need for grace through the Church, the precursors of
the Revolution preached sermons on the ultimate "per-
fectibility" of mankind through the exercise of reason.
Early in the century, English and French philosophes
had undertaken a general attack on organized religion,
the existence and nature of the deity, the credibility
of revelation. By 1789 this attack had gathered momen-
tum and its fire was concentrated almost solely on the
institution of the Church whose authority and function
it sought to displace. In reality, the French Revolu-
tion had become, as Alexis de Tocqueville noted more
than a century ago:

> ...a political revolution which functioned in the
> manner and which took on in some sense the aspect
> of a religious revolution.... It neither knew the
> boundary of country or language and was extended
> by means of "preaching and propaganda"...it con-
> sidered the citizen in an abstract fashion, apart
> from particular societies, in the same way that
> religions consider man in general, independently
> of time and place. It sought not merely the par-
> ticular rights of French citizens, but the general
> political rights and duties of all men...Since it
> appeared to be more concerned with the regeneration
> of the human race than with the reformation of
> France, it generated a passion which, until then,
> the most violent political revolutions had never
> exhibited. It inspired proselytism and gave birth
> to propaganda. It could therefore assume that
> appearance of a religious revolution which so
> antagonized contemporaries; or rather it became
> itself a kind of new religion, an imperfect religion
> it is true, a religion without God, without a form
> of worship, and without future life, but one which
> nevertheless, like Islamism, inundated the earth
> with soldiers, apostles, and martyrs. 1

Although Tocqueville's analysis of the signifi-

cance of the French Revolution is basically correct in

its major assumptions about the religious character of

the movement, it is not without some blind spots. It

is now generally held that the Revolution did have a

dogma, an appropriate liturgy or ceremonial, even a

litany of saints--the so-called "grands hommes" of the

Pantheon--fully as venerated as those of the old faith.

Sustained by a passionate and almost mystical faith in

the benevolence of the human race, it also developed
a belief in afterlife--the future--as expressed in its
concern for posterity. Moreover, an examination of the
art of the last quarter of the eighteenth century in
France provides concrete and ample illustration of the
"religious" aspects of the Revolution both in its offi-
cial artistic expression and in the undercurrent of
popular work produced especially between 1789 and 1795.

In order to carry the message of the Revolution
to the people it was necessary to develop an appropri-
ate artistic style or language. From at least 1750
onwards a form of "classicism" had claimed pre-eminence
over other styles both in the Academy and among educated
amateurs. The dominance of the classical education in
the eighteenth century had rendered possible its univer-
sality as a means of artistic expression. Whenever a
painter, writer or an orator had something significant
to say he generally invoked classical themes and forms.
In addition, the growth of philosophic scepticism had
made pagan martyrs more fashionable than Christians,
and Seneca had replaced Thomas Aquinas in the minds
of the dilettanti.

Accordingly, in 1789, the almost parliamentary
eloquence of neoclassical subjects like Oath of the
Horatii, Brutus with the Lictors Bearing the Bodies of
His Sons, Manlius Torquatus or the Death of Socrates
proved consonant with the preparatory, philosophical
phases of the revolutionary movement. Implicit in all
of these works was the inherited concept of their moral
usefulness. Indeed, their very utility only served to
reaffirm their beauty. However, the pattern of the
Revolution altered so swiftly that the content of the
official style so pertinent to 1789 or 1790 was by 1792
and 1793 virtually obsolete. The success of an official
style dictated that it remain in intimate contact with
political and social reality. A work like David's
Tennis Court Oath illustrates the manner in which the
style adapted itself to that reality--the result being
an increase in its artistic naturalism. By 1793, how-
ever, the inherited symbolic paraphernalia of ancient
Greece and Rome was inadequate to the task of bringing
to life the final and most enduring aspect of the
revolutionary religion--its cult of great men. To
meet the challenge of communication, the artist was

forced to deal more and more with personalities rather
than with ideas. Thus, the so-called martyr portraits
of David and others, which still display unity of form
and idea, nevertheless strike us as remarkably different
from the paintings of the 1780's or the extant _mises en
scènes_ of the contemporaneous philosophic _fêtes_ which
sought to involve the populace in the abstract cults
of Reason or the Supreme Being. Of these paintings
David's _Marat_ is so powerful in its naturalism that the
viewer is induced to forget, momentarily, the strict,
classical tightness of the composition and to concen-
trate on its stark, dramatic statement. Its underlining
of emotionalism may create the impression of imbalance--
an imbalance which was never directly perceived in the
"cooler" history paintings. Yet the painting represents
the final stage of neoclassicism as the official revol-
utionary style, before that style changed irrevocably.
With the advent of the Terror and the collapse of the
philosophic structure of the Revolution, the ideolog-
ical content of neoclassicism virtually disappeared.
The _salons_ which had reflected the progression of the
official style were abruptly canceled and an under-

current of artistic insecurity seems to permeate the
work of David as its major spokesman. His Self-
Portrait, c. 1794, and The Woman of the Market, c. 1793-4,
admit no comparison with paintings done one or two years
before, much less those of the 1780's.

Artists like David who had strongly committed
themselves to the Revolution's ideological program now
addressed themselves to purely aesthetic concerns. The
dedication to a beau idéal which had formerly implied a
bon idéal as well, no longer specified deep political
or philosophic commitment. The atmosphere of the Direc-
tory was such that the void created by the Revolution's
failure was not filled until the creation of the Empire.

In artistic circles discredited Roman heroes were
replaced by Hellenes or Celts. Paintings which former-
ly had had the urgency of a visual sermon were succeeded
by exercises in construction which testified to the
gradual divorce of form from subject matter. Divergent
artistic tendencies formerly existing as an undercurrent
checked by the overwhelming tide of the official style
now came to the fore upon the collapse of the rational-
ist utopia. Highly personal and expressionistic elements

took their place next to the rhetorical echoes of the official style in the salons of 1797 and 1799. By 1800 this twilight art, in which Sparta and Rome were exchanged for a lanquid Arcadia or the forest primeval, had effectively displaced the primacy of the official style's thematic content because that content was no longer philosophically applicable.

In a few years' time the subject matter of the tableaux d'histoire which had constituted the backbone of the official revolutionary art was divested of its moral character. The theoretical writings of the period, like those of Pierre Chaussard or Emeric David, reflect the shift in critical position. Classical art no longer serves as a guidepost for the artist because it is both good and beautiful--the latter characteristic is sufficient to inspire adulation. By 1810, the separation of form from content, of good from beautiful and of ancient from modern was complete, as evidenced by the creation in that year of the Decannal Prize to honor the great works of art produced since the beginning of the century. Two prize categories of paintings were established: tableaux d'histoire (ancient

history) and _tableaux représentant les sujets honor-_
ables pour le caractère national (contemporary history:
specifically, Napoléon). In this very designation of
type, the notion of utility had been transferred to the
contemporary works.

The ascendance of neoclassicism, especially in
the 1780's and during the Revolution, saw the triumph
of the philosophical spirit in the Fine Arts. This is
not to say that all neoclassic art was _per se_ philo-
sophic, but rather that the vanguard of neoclassicism
which produced the official style of the Revolution was
so imbued with principles borrowed from contemporary
philosophy that the collapse of these principles in the
social and political realm robbed the style of that
which had constituted its religious content.

The nature of the classical element had been
two-fold, encompassing both form and content. The lat-
ter, divested of it s philosophic commitment, easily re-
assumed its earlier non-moralizing character, leaving
artists to pursue either the purely formal aspects of
the antique or to utilize the complimentary naturalism
as a vehicle for the documentation of the great events
which contributed to the rise of the Empire.

CHAPTER I

It has taken centuries to subdue
the human race to the tyrannical
yoke of the priests; it will take
centuries and a series of efforts
to secure its freedom.[1]

Melchoir Grimm

In a remarkably perceptive collection of essays[2]
on the writing of history in general, and the history
of the Enlightenment in particular, the late Carl
Becker observed that "the rise of history and of science
were but two results of a single impulse, two aspects of
the trend of modern thought away from an overdone ration-
alization of the facts to a more careful and disinter-
ested examination of the facts themselves."[3] Certainly,
the modern student of history is conditioned to look
upon the period of the Enlightenment as one in whose
intellectual climate flourished a firm respect for the
facts, for the material reality of life, for an aware-
ness of the thingness of things. The writings of the
philosophes seem to abound in renunciations of the mys-
tical, abstract or superstitious aspects of Christian

thought and we are generally willing to take these
statements at face value. An examination of the philo-
sophic fraternity reveals a membership of sceptics,
agnostics, atheists and deists, who preferred science
to theology and regarded the existence of Christianity
as the greatest single obstacle to the improvement of
man's lot. We tend, in dealing with the contributions
of the philosophes to maximize their negativism, their
critical spirit, their ability to reduce an opinion, a
religion or a government policy to absurdity. Yet we
overlook the very religious basis of their ridicule.
What prompted their attack was not the absence, but the
presence of faith--a faith which was held to be superior
to existing, traditional belief. As Professor Becker
has pointed out:

> ...the Garden of Eden was for them a myth...they
> looked enviously back to the Golden Age of Roman
> virtue, or across the waters to the unspoiled
> innocence of an arcadian civilization that flour-
> ished in Pennsylvania. They renounced the author-
> ity of Church and Bible but exhibited a naive
> faith in the authority of nature and reason...
> They dismantled heaven, somewhat prematurely it
> semmed, since they retained their faith in the
> immortality of the soul...they denied that mira-
> cles ever happened, but believed in the perfecti-
> bility of the human race.[4]

In spite of inconsistencies and differences in approach, what unites the philosophes is their enthusiastic and fundamental belief in the ultimate progress of mankind in which they felt they were already participating.

In an essay, Eléments de Philosophie (1759), D'Alembert remarks that the intellectual life of the fifteenth through eighteenth centuries has been marked by significant turning points--always occuring at mid-century. He then goes on to inquire whether his observation cannot be extended to describe his own period and, in an interesting passage, provides a positive reply:

> The discovery and application of a new method of philosophizing, the kind of enthusiasm which accompanies discoveries, a certain exhaltation of ideas which the spectacle of the universe produces in us-- all these causes have brought about a lively fermentation of minds. Spreading through nature in all directions like a river which has burst its dams, this fermentation has swept with a sort of violence everything along with it which stood in its way... Thus, from the principles of the secular sciences to the foundations of religious revelation, from metaphysics to matters of taste, from music to morals, from the scholastic disputes of theologians to matters of trade, from the laws of princes to those of peoples, from natural law to the arbitrary laws of nations...everything has been discussed and analyzed, or at least mentioned.5

The words imply the presence of an intense force, one which perhaps is willful and incontrollable, but one which the philosopher is constantly striving to understand. Moreover, there is implicit in the writings of D'Alembert and other philosophes, a sense of direction, or goal--and that goal carries with it the idea of progress. In the eighteenth century, this will to progress, which was primarily conceived as intellectual progress but ultimately encompassed the social, political, technical and aesthetic spheres, found general expression in the word "reason." For the man of the Enlightenment, reason was both means and end. For the eighteenth century in general, a belief in the essential unity and permanence of reason was fundamental to the growing notion of progress and perfectibility. In the writing of the philosophes, reason assumed the character of divinity, and its practice, they affirmed, would change men into gods.

In the course of the century, the desire for scientific knowledge became the highest pursuit, and, as Ernst Cassirer had observed "the defense, re-enforcement and consolidation of this way of thinking is the cardinal aim of eighteenth century culture." Denis Diderot's

phrase "Pour changer la façon commune de penser,"
may be interpreted as the motto of the Encyclopédie,
but it was also the end to which all of the philosophes
dedicated their tremendous literary energies. The
avowed purpose of the desire for change was the belief
that human progress would inevitably follow through the
reign of reason. In order to create a climate favor-
able to the exercising of reason it was first necessary
to destroy the obstacles that stood in its path. Accord-
ingly, the publication of the first volume of the Encyc-
lopédie in 1751 was accompanied by the inauguration of
a vigorous, coordinated attack on the institutions and
ideologies of the old regime.

From at least the first quarter of the eighteenth
century, the church's teaching that man's nature was
sinful became a prime target of philosophic criticism.
Whereas philosophic writing in England and Germany is
more moderate in tone, French writers display early signs
of sharp skepticism and disdain. The Dictionnaire his-
torique et critique (1695-97) of Pierre Bayle and the Entre-
tiens sur la Pluralité des Mondes (1688) of Fontenelle al-
ready manifest some of the characteristics of the critical

spirit which grew throughout the 18th century and pro-
duces, at least in part, the decrees of Toleration (17.9),
the Civil Constitution of the Clergy (1791) and, ultimat-
ely a vast attempt to secularize organized religion.

By mid-century, the most vigorous attacker of
Christianity was Diderot whose special disdain was for
revealed religion and who delighted in pointing out the
discord which resulted from its reign over the world:

> [it] lies outside...and differs with every country
> and clime...[it] estranges father and son, arms
> man against man, and exposes the wise to hatred
> and persecution of the ignorant and fanatic...[7]

Diderot argued that natural religion's claim to superi-
ority over Christianity derived from its reasonableness
and from its universality by contrast to the former:

> Now the Jewish and Christian religions have had
> beginnings, and there is no religion on earth the
> date of whose origins is not known with the excep-
> tion of natural religion. This religion alone will
> not end while the others will perish...[8]

The main impulse to the natural religion des-
cribed by Diderot had come from England where in the
writings of Shaftsbury and especially of Tindal, the
sense of moral responsibility and a certain pragmatism
were united and determined the validity of religious
experience.[9] In France, the effect of these writings

was to stimulate both an attack on Christianity as the
organized religion and on religion _per se_. The majority
of _philosophes_ did not, however, intend to do away with
religion, but wished rather to reform it, to bring it
up to date and make it an instrument for the maintenance
of social order.

 After 1750 implied philosophic attack became
open warfare. In Helvétius' _De l'Esprit_ (1758) the
state absorbs organized religion, while Holbach's
Système de la Nature (1770) provides for the overthrow
not only of superstitious religions but of God as well.
In place of the church, the power of moral censure
resides within the framework of the social system:

> Thus the magistrate would become a useful priest
> and the legislator would also excercise a sacer-
> dotal function far more likely to result in the
> health of Nations than those who only speak of
> vain chimeras and teach false virtue.[10]

Rousseau, in his _Contrat Social_ (1762) maintains that
all morality is implicit in the state which he calls
a "panthéisme politique." In describing the necessity
for a secular or civil religion, he maintains:

> But there is a purely civil profession of faith, the
> articles of which it behooves the Sovereign to fix,
> not with the precision of religious dogmas, but treat-

ing them as a body of social <u>sentiments</u> without
which no man can be either a good citizen or a
faithful subject. [11]

A similar point of view, though more elaborate in
its design, is expressed in Mably's <u>Eglise</u> <u>d'Etat</u>.

In popular literature of the day one is struck by
the growing viciousness of the satires on the church and
religion. The jocular tone of a short poem by the Abbé
Legendre expresses the general apathy toward traditional
belief:

Some say the gods made men,
others say man made the gods,
As long as one will not find better,
stay there, as you are. [12]

As many historians have pointed out, nearly all
of the intellectual forces in the late eighteenth cen-
tury were opposed to the church. These include not
merely the enlightened bourgeoisie, but countless aris-
tocrats. In addition the many favours of European
sovereigns helped to elevate the position of the <u>philo-</u>
<u>sophes</u>, so that Voltaire could boast, with some truth,
that philosophic ideas were in ascendance from St.
Petersburg to Cadiz. In the <u>salons</u>, atheism or at
least some form of irreligious behaviour, was fashion-
able among the high nobility. Among the most celebrated

of the aristocratic non-conformists were the Duchesse de Choiseul, the Maréchale de Luxembourg, the Comtesse de Ségur, the Prince de Rohan, and the Prince de Conti, while among the clergy numerous abbés like Mably and Raynal were more sympathetic to the practice of reason and natural morality than to that of faith and the sacraments.

The French theatre, which, especially after mid-century, had become a vehicle for the expression of socio-political ideas, produced a number of anti-clerical and anti-religious plays, to mention only the better-known: St. Lambert's Les Saisons (1770), Le Blanc de Guillet's Les Druides (1772), L. L. Mercier's La Destruction de la Ligne (1772), and Jean Hennover (1771).[13]

The tone of the anti-religious attacks became so generally scurrilous that it provoked a great spate of apologetic literature, of which the pamphlets of Louis Antoine de Caraccioli are typical. His Cri de la Vérité contre la séduction du siècle (1765) and Voyage de la raison en Europe (1772) decry the triumph of what he calls "materialistic" reality and the wholesale abandonment of religious values.

Curiously, one point unites the defenders and detractors of organized religion in the eighteenth century. This is their mutual adherence to the principle of non-separation of church and state. In the Cri de la Vérité, the Christian apologist author defends the position of established religion. He cites Roman history and the rapport between institutions of church and state, and concludes his review by defining the relative sovereignty of each. So it is with the philosophes as well. There is scarcely one among them who advocates separation as we know it. For them the question of sovereignty is resolved as the role of religion is defined according to its social and political utility. For a writer like Voltaire, religion was a potential instrument for social order, subservient to the state, and by implication, reflecting the state's image. "Religion was only instituted to maintain order."[14]

The philosophes and the men of 1789 believed they could enlist the church in the service of the state and revolution, hence the enactment of the Civil Constitution of the Clergy in 1791. Yet the Civil

Constitution of the Clergy was not aimed primarily at converting priests into revolutionaries. Rather, it was indicative of an attempt to come to terms with the religious manifestations of a broad philosophic movement. In describing this phenomenon the distinguished historian of the revolution, Albert Mathiez, has observed:

> In combating Catholicism, the revolutionaries did not renounce their dream of moral and religious unity. They did not develop a lay mentality. At the moment they were reorganizing the civil establishment, they began to create and make official the cult of the fatherland.... This cult of the fatherland grew in proportion to the decline of constitutional Catholicism. When the latter lost its truly national character, the former had grown vigorous enough to replace it. This cult of the Fatherland...lasted...until the Concordat. What were its various names? Cult of Reason, Cult of Supreme Being...whatever the various names, it was to all intents and purposes the official state religion.[15]

The philosophic attack on the established order had always assumed, in addition to its call for destruction of the old institutions, that the regeneration of mankind would occur through the creation of a social program dependent on reason. Though the philosophes differed on the details of this program, they were virtually unanimous in the assumptions they made about its workability. Theirs was a common belief that man was

not an evil creature, that life on earth was its own
end, and, moreover, that man was capable of perfecting
himself and his environment through the exercise of
reason.

In the twenty or thirty years preceding the
revolution the philosophic quest for a common source
of morality--a source which would replace the traditional
religious sources--is dominated by two concerns: patri-
otism and posterity. Both are related to the philoso-
phic and historical concept of progress which was
expressed with consistency throughout the century, but
with increasing frequency from 1750 onwards. The philo-
sophes examined history, not merely, as they often pro-
fessed, to discover the universal principles of human
behavior, but rather to justify a system of values which
they wished to establish. In a sense, the study of
history was to the philosophes what the writings of the
church fathers were to the ecclesiastics. "History is
good for nothing," wrote Fontenelle, "if it be not
united with morality."[16] It was certainly among the
most useful weapons in the campaign the philosophes
waged against the false morality of Christianity.

As students of history in the Jesuit and Bene-
dictine colleges they had read the famous Greek and
Roman authors. Above all, they were introduced to
Spartan and Republican heroes through their familiar-
ity with Plutarch's _Lives_ which enjoyed special pop-
ularity after mid-century.[17] Montesquieu's _Considéra-_
tions sur les causes de la grandeur des Romains et de
leur décadence (1734) and Gibbon's _Decline and Fall of_
the Roman Empire, volumes of which appeared from 1776
to 1788, greatly contributed to their image of the
ancient past. The latter especially pointed to the
contrast between the virtuous eras of classical civil-
ization and the periods of darkness wherein superstition
and ignorance dominated peoples. The _philosophes_ could
join with Gibbon in decrying the reign of Christianity,
"I have described the triumph of Barbarism and Religion."[18]

It was commonly held in the eighteenth century
that at least four ages of enlightenment of virtue--
what Voltaire termed the "four happy ages" had existed.
These included the two classical periods, the Renais-
sance and the reign of Louis XIV. In addition, there
were other remote non-Christian lands--the Indies,

Asia and the Americas, amply described in the writings
of Raynal, Voltaire and Mostesquieu--wherein one might
study the superiority of natural morality to the false
morality of the established religion.

Though the new history served to introduce many
other versions of non-Christian cultures, it was the
vision of Greece and Rome that captured the spirit and
imagination of the philosophes--a vision of "une cité
antique, sobre, dure, égalitaire..."[19]

During the latter half of the century the recog-
nition by the philosophes that their own age represented
an improvement over the recent and medieval past contri-
buted to a growing aura of optimism. They surveyed that
past, compared it to the present and even presumed to
predict the future. What they outlined in such detailed
works as Condorcet's Esquisse du Progrès humain (1793)
and Herder's Auch eine Philosophie der Geschichte zur
Bildung der Menscheit (1789) is the possibility of even
greater improvement based on the selected experience of
the past. Thus, a preoccupation with the future and
with posterity is observable in their works and should
be related to developing concepts of civic morality.

In their interpretation of history, the philo-
sophes were by no means oblivious to the theory of
another world wherein the virtuous would find a proper
reward for a just life. Thus the worship of figures
or societies long past was inadequate to the needs of
a group which believed that a still better society was
to come. The philosophes recognized that "...without
a new heaven to replace the old, a new way of salva-
tion, of attaining perfection, the religion of human-
ity would appeal in vain to the common run of man..."[20]
The new heaven had to be located somewhere within the
confines of earthly life since it was an article of
philosophic faith that the aim of life was life itself,
i.e., the perfected temporal life of man. Man's sal-
vation was to be obtained through his own efforts, through
the cumulative improvements effected by successive gen-
erations of men. In this cooperative enterprise poster-
ity had an indubitable function: it would complete the
work initiated by the past.

This humanitarian concept of a link of past,
present and future and a preoccupation with the better-
ment of society persists in many forms throughout the

period of the enlightenment and even survives the pessi-
mistic retrospection of nineteenth century romanticism.
Its heritage can be viewed in a great body of philosophic
and political writings produced in the 1820's, '30's and
'40's. The most prominent of these works are those of
Edgar Quinet,[21] Simon Ballanche[22] and Jules Michelet.[23]
In addition to their expression of frequent nostalgic
longings for the great Revolution and for its great men,
such authors also echoed or revived the philosophe's
dream of a constantly improving humanity dominated by
some form of non-sectarian religion.

As in the late eighteenth century, this nineteenth
century philosophic revival had its artistic counterpart.
The ideas of Quinet and Ballanche were given visual
expression in Paul Chenavard's abortive scheme for the
decoration of the Panthéon in 1848.[24]

The consistent preoccupation with the improvement
of mankind which culminated in the Revolution, had, from
its inception, an aura of religious fervor. Ultimately,
it was not confined to the ennobling of individuals but
rather of nations.

The preoccupation with progress and posterity

produced a great body of literature of which the following are typical examples: the Code de l'humanité by Barbeu-Dubourg (1768), Dictionnaire sociale et patriotique by Lefevre (1769), Histoire du patriotisme français by Rossel (1769), Annales pittoresques de la vertu français by Turpin (1775-80), La morale du citoyen du monde ou la morale de la raison by the Abbé Sauri (1776) and the Morale naturelle and Catèchisme de morale, spécialement à l'usage de la jeunesse contenant les devoirs de l'homme et du citoyen, de quelque religion et du quel notion qu'il soit (1783).

These tracts and numerous others provided the basis for lectures and discussions in the salons, clubs, masonic lodges and learned academies, such as the Académie de Lyon,[25] where official public lectures on the themes of love of public welfare, Fatherland and the duties of a good citizen were presented with regularity from 1750 onward.

Moreover, the ideas and even the language of these patriotic and moral tracts are already quasi-religious, even, as Carl Becker has observed, approaching the Christian in tone.

Ancient history provided countless examples of
personal virtue and heroism for the followers of this
growing cult. Many intellectuals of the revolution-
ary generation, like Madame Roland[26], could weep at not
having been born Spartans or Romans and at having thus
been deprived of the opportunity of experiencing civic
virtue at first hand. Consequently, the study of his-
tory, imbued as it was with a special moral purpose,
assumed great importance during the latter half of the
century and provided many sources from which literary
and visual forms were to draw.

With the advent of the Revolution in 1789, jour-
nalists like Camille Desmoulins[27] were no longer exclu-
sively dependent on historical or biographical sources
in their efforts to inspire patriotism and call citizens
to arms. The decade had produced powerful visual prop-
aganda of its own. David's Oath of the Horatii, Death
of Socrates and Brutus with the Lictors Bearing the
Bodies of his Sons, along with lesser known paintings
of similar moralizing content, had captured the public
imagination and assumed the burden of instruction. In
the 1780's the language of Plutarch, Livy or Quintus

Curtius was translated into appropriate visual forms.

CHAPTER II

> If one wished to find at hand a partial
> explanation for this evolution, it would
> certainly be necessary to look to the
> works of the moralists and philosophers.
> One can establish that the taste for
> severity and so-called ancient austeri-
> ties was encouraged, even stimulated, by
> the introduction of moralizing in paint-
> ings, such as those of Greuze and in the
> unceasing exhortations of Diderot.[1]

The expressed desire of the philosophes was to
reform society by replacing the existing sources of
morality with a more perfect source. This desire
derived primarily from the general belief in the super-
iority of nature and reason to religious revelation.
It found expression in various guises, such as an
increasing preoccupation with civic or national virtue
and a concern with posterity. The fundamental princi-
ple of the new morality seems to have been the belief
in man's essential goodness and in his eventual pro-
gress through exercise of his reason.

The development of historicism and the creation
of a retrospective mentality unearthed numerous exam-
ples of societies wherein virtue flourished or was

thought to have flourished without benefit of Christi-
anity. Foremost among these societies were republican
Rome and democratic Greece whose institutions, litera-
ture and art captured the imagination and taste of the
time not merely because of their aesthetic values but
because of their related ethical values. Accordingly,
the second half of the century witnessed a great re-
vival of interest in antiquity, among encyclopedists,
among other men of letters, wealthy amateurs and, of
course, among artists. Although its most striking per-
iod of growth was the decade preceding the fall of the
Bastille, during the French Revolution this interest
achieved an official stamp of approval and an artis-
tic acceptance that carried its influence well into
the nineteenth century.

Looking at the various sources of the official
style in order to define its character more precisely,
one is struck by the large number of moralizing pictures
produced between 1760 and 1795 in contrast to the rela-
tive paucity of them in the first half of the eighteenth
century.[2] The subject matter of these pictures ranges

from the sentimental, bourgeois morality of paintings
by Greuze to a larger concern with civic virtue as
expressed, for example, in David's Oath of the Horatii
(Plate I). Moreover, the critical preoccupation with
goodness and with the moral purpose or function of
the work of art complements the philosophic search for
a higher and more authoritative source of secular
virtue.

The concern for the moral utility of art is per-
haps the most striking aspect of the development of the
later eighteenth century and transcends questions of
style and technique. While a comparison of the homely
"realism" of Greuze's The Punished Son (1778) (Plate IV)
with the idealized naturalism of David's Death of
Socrates (1787) (Plate II) reveals superficial differ-
ences, a fundamental resemblance is keenly felt in the
artists' sharing of a didactic purpose. Each work rep-
resents a response to one of the sources from which late
eighteenth century artists might have drawn inspiration:
the popular, emotional morality fiction on the one hand,
and the literature of the philosophic quest for human

perfection, on the other.

The precedents for the rational and moralizing tendencies in mid-eighteenth century painting had been established a century earlier. The seventeenth century provided numerous models of which Nicholas Poussin's history and mythological paintings are surely the best known examples. What was generally held by aestheticians to be the grand goût displayed characteristics described by Poussin himself as "consist[ing] of four things: subject matter, or theme, thought, structure, and style..."[3] Complementing the so-called academic spirit in the visual arts was a concern, expressed in literature and critical writings,[4] with being both reasonable and moral. Indeed it was believed that these characteristics could be projected visually or in poetry through the acknowledgement of rules--changeless rules, formulated in antiquity, whose universality was unquestionable. Much of what is generally described as the quarrel of the ancients and moderns, though also expressed in terms of form and technique, can be interpreted as an argument about discipline versus slackness, general rules versus personal invention and objective

naturalism versus subjective irrationalism.

Accordingly, from the period of Le Brun's domina-
tion of the Royal Academy of Painting and Sculpture
through the first half of the eighteenth century (des-
pite some encroachments from the Rococco) there was a
strong tendency to look to the art of antiquity as the
repository of aesthetic and technical perfection. In
addition, from about 1750 onwards, the artistic and
literary admiration of the ancients was boosted by
the philosophic. The philosophes had praised ancient
institutions as the expression of the most perfectly
formulated rules for human conduct; aestheticians pro-
claimed the moral grandeur and superiority of antique
art. Visual effects more and more were subordinated
to considerations of content. Form and technique were
viewed as the instruments through which the artist
might express an edifying or moving message. In the
Essai sur la Peinture Diderot passionately echoes this
concern with content: "First move me, astonish me,
break my heart, let me tremble, weep, stare, be out-
raged--only then, regale my eyes."[5]

Diderot subsequently amplified his views on the

importance of artistic content or subject matter in terms
of the ultimate function of art in numerous salons[6] which
are also, in part, a constant plea for the representation
of virtue. He was scarcely the first critic to be preoc-
cupied with the social and philosophic usefulness of a
work of art, but his views are exemplary of a general
attitude which greatly determined the character of the
official revolutionary style.

As the philosophes had exalted the importance of
reason as a weapon to combat the abuses and aberrations
of their age, artists and amateurs believed that any fri-
volity or emptiness in contemporary art could be overcome
by an adherence to the simplicity and truth of Greek and
Roman art. The product of a classical education, Diderot,
like other philosophes, was aware that the Greek philoso-
phers, Plato and Aristotle had examined the question of
artistic utility and had concluded that it was the artist's
duty to portray the good and the noble for his fellow
citizens.[7]

The first manifestation of the antique revival
were mainly of an archaeological nature. Literary interest
in the ancients had grown in the seventeenth century, but
general public concern with archaeological activities

did not develop until mid-eighteenth century. Before
the excavations of Herculaneum (1729, 38-80), Pompeii
(1739) and Paestum (1740-1760) had generated wide pop-
ular interest, publication of findings was limited.
A pioneer volume was Montfaucon's L'antiquité expliqée
et representée en images (1719-24). Montesquieu's
Considérations sur les causes de la grandeur et déca-
dence des Romains (1734) also contributed to the
increasing awareness of ancient art and institutions.
By mid-century this awareness had produced concrete
results. Listed chronologically, the following are
among the most important illustrated publications to
which young artists had access for their studies of
ancient models:

Piranesi	-Opere varie d'Archittetura (1748-89).
Caylus	-Receuil d'antiquités égyptiennes, éstrusques et romaines (1752-67).
	-Antichità di Ercolano (1757-).
Caylus & Mariette	-Recueil de peintures antiques (1757-83).
Leroy	-Ruines des plus beaux monumens de la Grèce (1758).
Winckelmann	-Geschichte der Kunst der Altertums (1764) French translations, 1766, 1785.

Winckelmann - <u>Monumenti antichi inediti</u> (1767)

Stuart & - <u>The Antiquities of Athens Measured
Revett and Delineated</u> (1762)

Chandler - <u>Antiquities of Ionia</u> (1769)

Soufflot - <u>Ruines de Paestum</u> (1764)

Hancarville - <u>Antiquités etrusques, grecques et
romaines tirés du cabinet de M.
Hamilton</u> (1766-67)

Volmey - <u>Voyage en Egypte et en Syrie</u> (1787)

David, F. A.- <u>Antiquités de la ville d'Herculaneum</u>
(1780-99)

These publications captured the imagination of
the revolutionary generation. They crossed over geo-
graphy and language to produce an aesthetic impulse
which was international.

A great impetus had been given to the reform
movement by the appearance in 1755 of the <u>Gedanken Uber
die Nachahmung der Griechischen werke in der Malerei und
Bildhauerkunst</u>. In its author, Johann Joachim Winckel-
mann, French and English artists were to find an eloquent
advocate of the technical and ethical superiority of
Greek art. Winckelmann's archaeological research con-

tributed not only a history of the development of Greek
art, but provided the aura of scholarship that was to
mark the mid-eighteenth century antique revival in con-
trast to earlier, fugitive interest.

Winckelmann was moved by Greek art because he
saw its beauty as the reflection of a perfect moral char-
acter. In the Gedanken he noted the "purity" of contour
lines and characterized the masterpieces of Greek art as
being recognizable through "noble simplicity and quiet
grandeur both in their pose and in their expression."[8]

The ultimate purpose of Winckelmann's extensive
research is clearly stated in the Gedanken. "Only by
imitating the Greeks can we become great, and indeed,
if this be possible, inimitable ourselves."[9] Winckel-
mann's words provided the antique revival with both a
goal or direction and the means to its attainment. It
remained only for this direction to be identified with
the contemporary aspirations of the philosophes. When
it was, especially in the decade before the revolution,
the official revolutionary style emerged. This is not
to say that all antique or neo-antique art became revo-
lutionary per se. An examination of the salons between

1780 and 1795 will reveal not only great variety in
the character of the works inspired by ancient art,
but also the presence of quite foreign artistic impul-
ses related, more or less directly, to the subjective,
non-moralizing style which persisted from the first half
of the century. Yet by the end of the '80's the philo-
sophic or ideological appropriateness of David's paint-
ings and those of his circle separated them from the
larger neo-antique or proto-romantic movements and
placed them at the service of the socio-political move-
ment.

Though the writings of Winckelmann undoubtedly
had greater impact on the developing official style,
especially during the twenty-five years following the
publication of the Gedanken, those of the Abbé Batteux,
La Font de Saint-Yenne and the Comte de Caylus, also
contributed to the theoretical foundations of the style.
Caylus, both as a collector who accumulated a vast
corpus of antique "models"--vases, gems, medals, sta-
tuettes, etc.--and as a would-be aesthetician and his-
torian who published several volumes to further appre-
ciation of the ancients, was in the vanguard of the

reform movement and even founded a _Concours_ to encourage the careful study of facial expression among students in the Academy in 1747.

His _Nouveaux_ _Sujets_ _de_ _Peinture_ _et_ _de_ _Sculpture_, published in 1755, is concerned with subjects appropriate to art and to its aims. Its author seems to suggest that these subjects are "new" because their content is of a higher moral fibre than those found in contemporary art. Caylus is explicit in his requirements. He eschews indecent and what he calls "revolting" scenes, such as those of plunder or rape and suggests those of positively virtuous character: scenes illustrating filial respect, the admiration of peoples for their leaders, the building of temples (which shows respect for religion, according to Caylus), etc. Caylus further requires that the new subjects possess grace and charm as well as nobility of attitude. The young ladies of Sparta or of the Sacred Island are cited as fine subjects in "the nobility of their poses and simple attire."[10] In speaking of subject matter drawn from Roman history, Caylus expresses the opinion that virtue can be personified or epitomized in a single figure.

Virtue, he says, "is a noble Roman whose face must be
sweet and grand."[11] His argument for the use of a
single figure to exemplify moral superiority is inter-
esting because it prefigures one of the crucial develop-
ments of the official style during the revolution--
the martyr portrait.

Caylus is quite specific in his observations
regarding the execution of the nouveaux sujets. He
advocates simple outlines and the representation of
clear and generally descriptive drapery.[12] His ten-
dency to recommend a relief-like solidity of forms
coincides with the views of Winckelmann. In the
Parallèle de la Peinture et de la sculpture (1748),
Caylus decries the artistic abuse of drapery during
the Baroque. In speaking of Bernini he deplores the
arbitrary draperies in his sculpture--"This innovation
has had dangerous consequences,"[13]--and urges a return
to antique clarity.

Far more interesting than his views on technique
and subject matter, though closely connected with the
latter, is Caylus' belief in the destiny and function
of the work of art. Painting and sculpture, he says,

must surpass mere imitation of nature and transmit to
posterity "...the great examples of morality and hero-
ism."[14] Moreover "...the monuments of antiquity have
often been the source of the greatest virtue: for it
is known that living examples or those too familiar do
not make the same impression in men as those works of
ancient sculpture erected to virtue and glory."

(In addition to his writings), Caylus' influence
on the Academy, especially on its method of instruc-
tion, must also be recognized. Apart from the signi-
ficance of his Concours, and its encouragement of
naturalism, his promotion of the antique had a direct
effect on young artists. Before 1750 the study and
copying of the antique were "recommandées" by officials,
shortly thereafter they were imposed.[16]

The writings of La Font de Saint-Yenne compate
in critical tone with those of Caylus. In his Réflexions
sur quelques causes de l'état présent de la peinture en
France (1747) La Font reaffirms the primacy of history
painting:

> Of all the categories of painting, the first is that
> of History painting: the painter-historian is the
> only painter who paints for the soul; the others
> only paint for the eyes..."[17]

In *Sentiments* *sur* *quelques* *ouvrages* *de* *peinture* ,

sculpture *et* *Gravure* La Font speaks once again of the

necessity of developing a grand style of history paint-

ing which will represent:

> ...the virtuous and heroic actions of great men,
> examples of humanity, generosity, greatness, courage
> ...the passionate enthusiasm for the honor and well-
> being of the Fatherland.... [18]

Another writer whose work had considerable impact

on the revolutionary generation of artists was the Abbé

Batteux. In *Les* *Beaux* *Arts* *réduits* *à* *un* *même* *principe*

(1746), which reflects the eighteenth century desire

to formulate fundamental principles or rules which

would be both universal and subordinated to one basic

rule, Batteux uses Horace's observation "ut pictura

poesis" as a point of departure for his views on the

essential correspondence of the arts. The principle of

the parallelism of the arts and sciences, long one of

the tenets of French classicism, is even extended by

the author to take in music and acting as well. Batteux's

book is divided into three parts: the first is con-

cerned with the character and aim of the arts. In fami-

liar eighteenth century fashion, the author establishes

the imitation of nature as that common aim. Part II

is devoted to an examination of the functions or con-
tributions of goût and raison wherein Batteux is par-
ticularly explicit about the necessary ordering proper-
ties of the latter. Part III, entitled "theory verified
by practice," lists the prerequisites for perfection in
painting.[19] For Batteux, as for Caylus, le dessin is the
dominant element in painting, and like Caylus, Batteux
also cites the painter's inevitable and laudable imita-
tion of the relief.

In the great body of eighteenth century writing
which deals with aesthetics (and more specifically with
the integration of art and society) the recurrence of
certain ideas is significant. Among these, the notion
of contemporary inferiority both in technique and con-
tent in comparison to ancient art is given emphasis as
well as the belief that visual beauty is not enough and
that a work of art must be committed to a higher pur-
pose: the edification and uplifting of mankind. Later
eighteenth century art criticism is more and more marked
by the advocacy of technical reform in concert with
reform of subject matter. Further, that preoccupation
with the destiny or purpose of art, typical especially

of the writings of the philosophes, led them to praise
works which suggested a philosophic commitment. Though
one cannot deny that the pseudo-classical subject matter
of salon paintings from the 1760's and 1770's contained
much that was light and even as slyly sensual as many
Rococo paintings, the presence and the gradual increase
in number of more serious, didactic works is significant.

In fact, these differences should not obscure
the persistence of a trend, observable from the late
'60's on. It may be superficially true that Challe's
(1761) Death of Socrates contained elements more baroque
in style than David's painting (1787), but what is much
more interesting and pertinent is the very appearance
of this subject in the 1760's, its selective representa-
tion from that time, and the impact it had on the con-
temporary viewer.[20] One could cite other equally pop-
ular subjects, but this one enjoyed extraordinary favor
because the figure of Socrates which expresses both
the ancient attitude toward death and the personifica-
tion of personal excellence or virtue is one with which
the philosophic mentality immediately identified and
for which the revolutionary could feel sympathy.

Diderot had expressed less concern with visual
effects in a painting than with its power to move or
affect men. In his Salon (1761), Diderot praises
Challe's Socrates Condemmed to Drink the Hemlock for
its assimilation of the accepted hallmarks of ancient
art:

> One might say it was a copy of an ancient relief.
> A simplicity reigns (in it); a tranquility, above
> all in the principle figure, which is not at all
> of our time.[21]

But even more meaningful to Diderot and his
generation was the lesson or moral imparted by the
painting, for, as Jean Seznec has observed, the
"philosophe was incapable of separating the sphere
of art from the sphere of life."[21a] Diderot himself
summarizes:

> If the role of a person is noble, great and beau-
> tiful in a play or a painting, why should it be
> impractically ridiculous in real life?[22]

It is possible to trace the evolution of Diderot's
thoughts regarding the moral responsibility of art. In
1745, he had translated and annotated Shaftsbury's Essay
on Merit and Virtue and his Salons, dating from 1759,
contain many allusions to William Hogarth's Analysis of
Beauty (1753).[23] The English preoccupation with the

equation of goodness and beauty found expression in his
Salon of 1759 in the assertion that the task of art was
"to honour virtue and expose vice,"[24] It can also be
detected in Diderot's *Essai sur la peinture* (1765)[25]
and in his articles notably, *Art* and *Beau*, for the
Encyclopédie.[26]

Diderot is the most eloquent if not the most con-
sistent advocate of the moral function of art and, though
his observations are scarcely unique, they had profound
consequences for the revolutionary generation. Moreover,
although he disdained the "antique fanaticism" of Caylus
and Winckelmann, Diderot's recognition of the moral char-
acter of ancient art comes remarkably close to their views
and these were the views which formed the theoretical
foundation of the official style.

Diderot never traveled to Italy, but he was
familiar with ancient art in its contemporaneous manifes-
tation. Of the main pulications of the antique discov-
eries the *Antichita di Ercolano* (1757) is given special
notice in the article, *Art*, in the *Encyclopédie*, and in
his observations on Joseph Vien's painting, *La Marchande
d'Amours* which was exhibited in the *Salon* of 1763.

Inspired by one of the paintings reproduced in Volume

III of the <u>Antichita</u>, Vien's work excited the following

response from Diderot:

> How well everything works in the ancient style.
> The interest ... is conveyed
> with infinite intelligence... There is an
> elegance in the verses, in the bodies, in the
> facial expressions, in the costumes, a tranquil-
> ity in the composition, [there is] finesse....[27]

In this brief excerpt, Diderot reveals attitudes

similar to those found in Caylus and Winckelmann, espec-

ially in his praise of "tranquillité"--a characteristic

greatly valued by the latter. Similar also, is

Diderot's appraisal of the achievements of antique art.

Sculpture receives his highest praise, and he presumes

that the excellence of ancient paintings stems from the

excellence of the sculpture on which they were depen-

dent.[28]

For Diderot, as for so many other late eighteenth

century critics, technical considerations, though impor-

tant, are secondary to those of content. The justifica-

tion of a work of art is the tone of its message--what

it does to improve or ennoble men. Thus, for Diderot's

generation, the ultimate reason for the superiority

of ancient art was the ethical motivation attri-

buted to it by its critics. For a _philosophe_ like
Diderot the character or tone coincides, moreover, with
the aims of the secular religion developing as an alter-
native to Christianity. He therefore recommends the
antique as expressing both a moral and esthetic way
of life--a way of life more sublime than the Catholic.
"Noble and great, that is the tone of the antique."[29]

But nobility was not confined exclusively to the
antique, and the crusade for greater moral content in
art also received an impetus from two different, but
related sources: English sentimental literature and the
doctrines of J. J. Rousseau. The works of Samuel
Richardson, especially his _Clarissa_ and _Pamela_, achieved
extraordinary popularity in France where their preoccu-
pation with persecuted virtue and related suffering
found sympathetic response. Rousseau's _Nouvelle Héloise_
(1761) was followed by a spate of moralizing romances.[30]
Among the other numerous and relatively insignificant
works, a few titles are interesting because of their
illustrations which reveal a strong personal and often
irrational impulse. Salomon's[31] engravings for Baculard
d'Arnaud's _Epreuves du Sentiment_ (1770) display a

<u>tristesse</u>, which is asserted with increasing frequency
and on a grand scale in painting after the collapse of
the Revolution. The illustrations celebrate a kind of
languid suffering which borders on the macabre in con-
trast to the more positive, healthy subject matter of
the official style. In a suite of engravings done by
J. M. Moreau (called le Jeune) for <u>Les</u> <u>Mois</u> of de
Roncher (1779), the conventionally classical attitudes
and dress suggest an exposure to the antique, but the
setting is melancholy and tenebrous in the extreme.
An examination of the graphic art produced in France
between 1770 and 1800 reveals the posibility of much
greater artistic freedom and the presence of a proto-
romanticism which was only partially stifled by the
official style. This freedom finds specific manifes-
tation in the artists' reaction to the antique.

Subsequently the intermingling of virtue and
suffering found in the popular graphic art would undergo
a transformation resulting not only in the brutal and
perverse literature of the "divine" Marquis, but in the
vicious and often disgusting caricatures which document

the political collapse from 1791 to 1794.

Morality in painting, if it was not antique in inspiration, was, like its English or Swiss source, bourgeois. The paintings of J. B. Greuze are populated with peasants or petit-bourgeois whose attitudes of nobility emulate those of their Greek and Roman betters. The gestures and expressions found in a work like Greuze's The Punished Son (1778) (Plate IV) especially in the distracted woman to the left of the dying father, the woman who holds her arm and the kneeling son do not seem, apart from their contemporary dress, any less "classical" in their behaviour than figures in paintings by the Roman eclectics; furthermore, if one were to compare this work to an early David of ancient subject matter, say, Antiochus and Stratonice (1774) (Plate V), a case could be made for the greater adherence to classical form and organization in Greuze's work. In spite of a tendency towards a certain literalism, its planar space, its relief-like grouping of figures and its closed-off simple background reveal the artist's awareness of seventeenth century classical models. The figures are surely more solid, the drapery and anatomy more descrip-

tive and the lighting less obviously Baroque than in
David's Prix de Rome picture. Even a later work of
David's, his reception piece for the Academy, the
Andromache Mourning over the Body of Hector (1783)
(Plate VII), seems more cluttered, painterly and less
measured in its spatial references than Greuze's
Punished Son. However, and in spite of its compara-
tive virtues, significant inferiority lies in the
concept or moral intention of this painting. If we
are at all impressed emotionally by the scene, it is
with a sense of family or group tragedy. No single
figure really dominates the shallow stage, and the
result is almost that of a homely anecdote showing the
 spectator the pathetic consequences of some ill-con-
sidered but ultimately minor act. The visual sermons
of Greuze recall the confiding, humble morality of
Samuel Richardson's popular novels in which all figures
participate, whereas in the antique subjects, morality
is frequently personified and the virtuous example is
isolated from all others. The martyred Socrates of
David's painting is the embodiment of virtue rejected
by a corrupt society. Those who faithfully surround

him at the end, are, strictly speaking, background
figures serving only as foils for this solitary, dra-
matic figure.

Though the level of intellectual content differs
from the sensuous, vague and often erratic illustrations
to popular romances, to the heart-felt visions of Greuze,
and, finally, to the "philosophic example" of David and
other imitators of the antique, the predilection for
moralizing is constant in all. We have observed that
the interlinking of suffering and virtue led to some
strange distortions or aberrations expressed in both
the literature of the period and in its graphic art.
Even the middle-class morality of Greuze's paintings
persisted in the numerous genre subjects executed during
the Revolution which referred to contemporary events.[32]
In the same decade, the official art which found its
primary inspiration in the antique possessed a unity
of form, content and function. Thus the slightest
alteration in any of these areas might bring about the
disintegration of this unity. Unlike either the intense
subjective emotionalism of late eighteenth century gra-
phic art or the anecdotal, familial morality of Greuze,

the best of the official style was involved with problems
of a universal scope and attempted to formulate a lan-
guage equivalent to these problems. As such, it can
be argued that it represented not the beginning of a
modern attitude, but rather the last statement of an
old one. Where Greuze dealt with the reality of accum-
ulated petty detail and the graphic artists of the pop-
ular romantic literature dealt with the fugitive realities
of emotion and spirit, the proponents of the official
style in their evocation of classical forms and subject
matter, utilized properties both intellectual and phy-
sical, abstract and organic, real and ideal. This very
usage postulated a permanence which, as it happens, con-
trasted with or perhaps resulted from a reaction to the
decaying impermanence of late eighteenth century society.

Like the philosophes who sought after a final
and perfect social and political system, the artists
and theoreticians of the official style were in quest
of perfect guide rules for a perfect art. In his
famous Préface to the Salon of 1767, Diderot articu-
lates this concern with reason and order.

> In order to be really good, a painting must be as
> carefully reasoned as an exercise in metaphysics.[33]

As we have observed, the Comte de Caylus and
Diderot, foremost among the critics, worked for reform,
the ennoblement of style and the resuscitation of the
grand goût--especially through the rehabilitation of
history painting. Their efforts met with tangible
success when, in 1775, Comte d'Angiviller, the Direc-
tor General of the King's Buildings
began to draw up a program for raising the quality of
painting and scupture in the Academy to a more digni-
fied historical level.[34] D'Angiviller attempted to
promote higher quality through encouragement, namely,
through royal commissions of paintings and sculpture
for every salon in the Louvre.[35] The subject matter
chosen for these commissions is significant, not only
because of its obvious relation to the antique revival
but because of its reflection of the upsurge of interest
in the French nation and its great men. A brief com-
parison of the dates of literary works exhorting public
virtue, patriotism and their rewards with those of
d'Angiviller's projects reveals at least a part of their
background.

Though the administrations of Lenormant de

Tournahem (1745-1751) and of the Marquis de Marigny
(1751-1773) were marked by attempts to revitalize
history painting[36] and saw some innovations in aca-
demic instruction as well,[37] no concerted effort had
been made to raise standards through a program of
royal encouragement. Tournahem and his artistic men-
tor, Charles Cochin, introduced some reforms in the
Academy, especially in the recruiting of students, and
Marigny's regime was marked by a more consistant effort
at revitalization and reform--particularly as an attack
against the sensousness of Rococo painting.[38] However,
with the exception of the abortive though ambitious
decorations for the Chateau of Choisy (1764)[39] no nota-
ble historical or allegorical cycle was forthcoming, nor
had there been any person's official recognition of the
need to "awaken virtue and patriotic sentiment,"[40] as
d'Angiviller subsequently proposed. In his plan to
encourage higher standards in painting and sculpture,
the director specified that the subjects which would
contribute to the dignity of the arts were to be drawn
from ancient history and from modern French history.
Of these, two were to deal with religious piety as
exemplified by the Greeks and Romans (cf. Caylus) and

these were awarded to Durameau and Lagrenée, the younger,
respectively.[41] Another subject, ceded to Brenet, was
the encouragement of work by the Romans, while their
reward of virtue was assigned to Lepicié.[42] Two of the
modern paintings which were given to Brenet and Durameau
were: Du Guescelin, sa mort, honneurs rendus à sa valeur
et ses vertus par la ville de Rancon and La Conti-
nence de Bayard. The subject matter of the sulptures was
to have been based exclusively on persons and events from
French history. The particular emphasis is explained by
D'Angiviller in a previously quoted letter to his friend,
the Premier Peintre du Roi, Pierre:

> Until the present it seemed as though one ignored
> the potential resources of our (country's) history
> in providing subjects for painting.[43]

The paintings mentioned above, along with the
sculptures of grands hommes of French history, were
exhibited in the Salons of 1777 and 1779. In addition,
from 1777 to 1789, every two years, eight to ten history
paintings were commissioned. Some were ancient, some
modern.

The character of the paintings and sculptures which

resulted from this first attempt at systematic official encouragement varied from traditional, pseudo-classical attitudes of repose, to specific attitudes reflecting a decisive or significant moment. The notion of the superiority of the latter type of representation had been expressed by Watelet in his article, Dessin, in the Encyclopédie.[44]

The idea of the series had great consequences for the growth of the official revolutionary style. Stemming in part from the late eighteenth century interest in Plutarch and the contemporary concern with France's own "hommes illustres," it provided the precedent for what was to follow. Moreover, it illustrates again that preoccupation with secular morality and the tendency to express this preoccupation in terms of great figures which was the hallmark of the succeeding decades of revolutionary art.

CHAPTER III

Antiquity will not seduce me, it
lacks warmth, and does not move.[1]

It has been argued that with the exhibition of

David's Oath of the Horatii in the Salon of 1785, the

triumph of neoclassicism over the rococo was complete.

Louis Hautecoeur has called the painting the "manifesto"

of the new style[2] and no less a source than the contempor-

ary, popular journalist, the Père Duchène, maintained

that the painting "had inflamed more souls for liberty

than the best books."[3] If these appraisals seem exag-

gerated, an examination of the salons held between the

years 1781 and 1789 reveals at least the steady rise

in influence of neoclassicism and of its chief spokes-

man.

In 1781, after he had returned from a five-year

sojourn in Italy as a Prix de Rome winner, David was

accorded the status of agréé by the Academy.[4] His

Blind Belisarius (Plate VI) was exhibited, along with

a sketch for the Funeral of Patroclus and some figure

studies, in the salon of 1781, and was enthusiastically received by Diderot,[5] and Grimm,[6] amoung other critics. In the same year David opened an atelier in the Louvre and his first pupils included Girodet, Fabre and Drouais. Two years later he repeated the success of the Belisarius with his Andromache Mourning over the Body of Hector (Plate VII) which served not only as his entry in the salon but as his reception piece when he became an Académicien on August 23, 1783.[7]

If the Blind Belisarius had initially suggested the new philosophic spirit in art with its combination of moralizing and didactic content and its rational, Poussinist forms, the Oath of the Horatii (Plate I), painted in 1784 and first exhibited in David's studio in the Piazza del Popolo in Rome,[8] with its austere, hard forms and logical space and its concern with original costumes and furnishings dominated the salon of 1785 in competition with such ancient subjects as Vien's Return of Priam, Peyron's Dying Alcestis, and Barthelmy's Manlius Torquatus.

David had begun work on a painting entitled Horace Defended by his Father before his election to the

Academy.[9] During the 1770's and 1780's, performances
of classical tragedies by Corneille and Voltaire were
everywhere in vogue.[10] Moreover, David like others of
his generation had frequent recourse to Plutarch's _Lives_
and to the histories of Livy and other Roman writers.[11]
Though the prose of the historians or dramatists might
have been too elevated for the lower class Frenchmen,
the language of David's pictorial sermon was straight-
forward.

Walter Friedlaender has described the work as
rallying the moral, aesthetic and political "aspira-
tions of a period,"[12] and contemporary critics were
captivated by the wedding of form and content which at
last satisfied their aesthetic and ethical standards.
Here was precision, clarity of space and contour and
the relief-like, sculptural quality of which Caylus,
Batteux, and Diderot so heartily approved. The call
for reform of the _grand goût_ had finally been answered.
But in addition, rising far above the level of the
ever-increasing number of classical and moralizing
history paintings, David had effectively projected the
concept of personal and public excellence into a power-

ful and moving political document. The Oath of the
Horatii was hailed as a masterpiece and its author was
called, in obvious reference to the author of the pop-
ular classic drama, Horace "the Corneille of painting,"[13]
and the "real victor of the salon."[14]

Joseph Vien, Director of the French Academy in
Rome, and an early formative influence on David through
his use of ancient themes and his imitation of classi-
cal sources,[15] had taught David the rudiments of the
new, severe composition. Acquaintance with the Scots-
man, Gavin Hamilton, the German, Anton Raphael Mengs[15a]
and study of the paintings of Raphael, Michelangelo,
Caravaggio and the Bolognese contributed variously to
the development and refinement of his vision as did his
direct exposure to sculptures both antique and neoantique.[16]
Five years spent in Rome in the company of the neoclassi-
cal theorist and friend of the sculptor, Antonio Canova,
Antoine-Chrysostôme Quatremère de Quincy, produced tangi-
ble results in his paintings and in his later views regard-
ing the function and destination of works of art. Contem-
porary memoirs[17] attest to David's familiarity with the
influential writings of Winckelmann as well as the pub-

lications of Montfaucon, Hamilton and with the contempor-
ary Roman collections as well as existing relics of
ancient art.[8]

David's sketches from his Roman sojourns provide
interesting insights into his sources of inspiration
which ultimately furnished him with a basic repertory of
antique types and details. Yet all of this provides only
a partial explanation of the complicated process of welding
philosophic ideas or concepts into visual expressions.

There was a prodigious number of ancient history
paintings in the salon of 1787. Among the most important
of these were Vincent's Clemency of Augustus, Regnault's
Virgil Reading the Aeneid to Augustus and Octavius,
Peyron's Curius Dentatus and the Samnites, Le Barbier's
drawing for the Combat of the Horatii, Vincent's Belisarius,
Perrin's Death of Marc Anthony, Monsiau's Death of Phocion,
Brenet's Continence of Scipio and two paintings of the
Death of Socrates by Peyron and David (Plate II).

The latter were the twin lights of the exhibition.
In his comparison of the two paintings, a con-

temporary critic characterized Peyron as "a profound
philosopher"[19] while he praised David as "a great logi-
cian."[20] Though David's painting was not as great a
public success as the Oath of the Horatii, it received
considerable critical acclaim. The noble subject of
Socrates had long been a popular one with philosophes,
notably Diderot,[21] but the enthusiastic response to
David's paintings extended beyond the boundaries of
Parisian literary and artistic society. Sir Joshua
Reynolds compared David's achievement in this work to
that of Raphael in the Stanze and Michelangelo in the
Sistine Chapel and proclaimed "...this canvas would have
gained all honor in Athens at the time of Pericles.
This picture is in all ways perfect."[22]

David's Paris and Helen (Plate VIII), painted in
1788 for the Comte d'Artois, represents a momentary
lapse from an otherwise consistent preoccupation with
moralizing tableaux d'histoire. Formally, it is depen-
dent on a Poussinist definition of space through suc-
cessibe parallel planes. The figures are conceived in
a manner softer and fleshier than those in either the
Oath of the Horatii or the Death of Socrates, the color

is reminiscent of David's mentor, Vien. Yet apart
from the comparatively frivolous subject matter and
the use of pseudo-antique rather than original sources
in the architecture, the scholarly, archeological con-
cern with detail evidence in the couch, brazier, and
Phrygian cap, bespeaks an attitude of seriousness.

No contemporary of David's could rival him in
prestige nor in the amount of influence produced by
his tableaux d'histoire. Though he never possessed the
title premier peintre du Roi which previously had been
both the official and real stamp of artistic power, he
was, by the summer of 1789, surely as powerful and
influential an artistic dictator Charles le Brun had
been during the seventeenth century.

The year was to have a particular significance
for David not only as the major artistic figure but
as an effective political activist as well.

A royal edict had set the date of May 1, 1789
for the convocation of the Estates General. Dele-
gates arrived at Versailles armed with cahiers of
grievances. It had been generally hoped that the
Estates would undertake a comprehensive program of

constitutional reform. On the main points of this
reform there was broad agreement between the three
Estates that there should be 1) an hereditary monarchy
but one limited in power, 2) a representative assembly
which would meet at specific periods and supervise
taxation, legislation and administration, 3) propor-
tionately equal taxation for each of the Estates, 4)
establishment of the citizen's basic civil rights, i.e.,
freedom from arbitrary arrest and imprisonment, trial
by jury, freedom of speech, the press, and religion
(not all the clergy accepted the last two points),
and 5) the decentralization of the government by grant-
ing of greater authority to local governments.

The need for a fundamental agreement on the
method of seating delegates was the most important
problem facing the delegates. The representatives of
the third estate argued that France had no constitution,
that they had convened to create a constitution and
therefore all three classes should sit in common assem-
bly. They agreed that this conclusion was based on
natural law and reason.

After five weeks of violent disagreement on the

question of seating and organization, the third estate

began to verify credentials declaring themselves the

representatives of the nation in a National Assembly.

On June 19, they were joined by a majority of the clergy.

On June 20, the delegates of the third estate found the

doors to their assembly room closed presumably to allow

for repairs. Nearby was an indoor tennis court and

there the deputies assembled and swore an oath not to

separate until the "Constitution of the realm was estab-

lished and affirmed upon a solid basis."[23] In the midst

of the group, Bailly, an astronomer and savant who was

presiding officer, read the oath and the deputies swore

after him. Thus the Tennis Court Oath served warning

that the revolution had already begun and that it would

proceed in an atmosphere of resolute determination. Sub-

sequently, a majority of the clergy and a sprinkling of

nobles joined the third estate. On June 27th, after a

series of threats and hesitations, Louis XVI ordered

the remaining clergy and nobles to join the delegates of

the third estate in a National Assembly. Thus the

Estates General ceased to exist and the union of the

three classes in a genuine representative assembly was

accomplished. The assembly quickly involved itself
in the business of creating a committee on constitu-
tional procedure or National Constituent Assembly as
it was designated. In the meantime, under advice from
conservative ministers, Louis ordered a buildup of
military strength in and around Paris as a prelude to
dissolving the Assembly. The resulting mood in Paris
was one of disquietude and then hostility when Louis
dismissed his finance minister, Necker, who was pop-
ularly regarded as a liberal.

In Paris, the center of popular agitation was
the Palais Royal which belonged to the Duke of Orléans,
a liberal sympathizer.[24] It was there that the mutinous
regiment of French guards who had refused to attack
demonstrators against the kings' policy gathered.
There also was a young journalist, Camille Desmoulins,[25]
who exhorted the crowds to arm themselves. The night
of July 12 there were violent demonstrations in the
name of Necker and the Duke of Orléans, and by July 14
there were rumours that vast stores of arms could be
found at the Hotel des Invalides and at the Bastille.
Mobs struck out for both.

The governor of the Bastille was prepared for the mob and consequently no attack came for hours. Then as a result of a misunderstanding between the garrison commander and the representative of the civic militia which covered the mob, an unarmed delegation was fired on within the confines of the fortress.[26] What followed was a brutal carnage in which the Swiss guards, defenders of the Bastille, were virtually all killed and their bodies mutilated in a manner which was to set a precedent for the violence that followed.

The following day, Louis XVI recognized the victory of the mob. He went before the Assembly and reported that he had ordered the royal troops to leave Versailles and had reinstated Necker. Appearing before the new municipal government of Paris, in the company of the newly renamed National Guard[27] he recognized the liberal, Bailly, as the mayor of Paris and even donned a tricolor handed to him.

Such was the atmosphere in Paris when the salon of 1789 opened in the great salle of the Louvre.[28] The number of neoantique paintings increased in general but in particular among the category, tableaux d'histoire.

Prominent among those exhibited were Vien's Offering

to Minerva, Vincent's Zeuxis and the Wives of Crotonus,

Perrin's Death of Seneca, Monsiau's drawing for The

Suicide of Cato. Among the works exhibited with con-

temporary themes were two notable sketches by Moreau

le Jeune and Durameau of the Opening of the Estates

General. But the greatest excitement and public inter-

est were fixed on David's The Lictors Bearing the Bodies

of Brutus' Dead Sons (Plate XI). This painting had

been ordered by Louis XVI as a replacement for one of

Coriolanus which David was to have exhibited in the

salon of 1787.[29] The timely appeal of the subject

matter could hardly have gone unnoticed, for Brutus,

one of the founders of the Roman republic forced him-

self to order his sons' death when they betrayed the

republic.[30]

The painting arrived late, after newspapers had

reported that the Director of the King's Buildings,

d'Angiviller, had prohibited its exhibition.[31] Though

this report was untrue, the rumor only resulted

in heaping further praise on the work. The National

Guard was called in to insure the installation of the

canvas[32] and it thus achieved the status of a revolu-

tionary symbol. Speaking of this association, Fried-

laender observed:

> Even less than with the Horatii did the furor
> around it depend upon any appreciation of
> artistic values, for the picture is much less
> well-knit...It was the picture's antiquarianism
> and careful observation of what was called
> "costume" that was admired.[33]

Indeed the head of Brutus had been modeled after

a Capitoline bust, the statue of Roma and the Romulus

and Remus reliefs were from another antique original[34]

and the furnishings and clothes were archaeologically

correct. It was, however, a different aspect of the

work which enabled David to:

> talk to the people more clearly than all the
> inflammatory writers whose work the regime has
> confiscated and burned.[35]

Typical of the critical reaction to the painting

is the following contemporaneous report:

> I have been impatiently awaiting the arrival of
> M. David's Brutus. If it had come a bit sooner, I
> would have covered it with praise. Here is the
> first work of genius to come from the modern school.
> What somber indication of remorse in the pose and
> facial expression of the father.... What majestic
> and tranquil severity in the cortege which accompanies
> the bodies. What art in composing a work which
> unites three separate moments in one powerful
> scene.... This work places David between Corneille
> and Shakespeare....[36]

The observations quoted here and previously
underline the major reasons for David's artistic
ascendancy. He, more than any other artist, succeeded
in fusing the moralistic and antiquarian into a power-
ful political broadside. Both the practitioners of
neoclassicism and the framers of the revolutionary
ideology were convinced of the value of reason and
order--the one in order to create a perfect art, the
other in order to create a perfect society. We have
observed that the philosophes also viewed reason as
a practical tool and that a number of philosophically
oriented critics had imbued art with a practical
character insofar as they stressed its utilitarianism,
its destination. By 1789, that destination was clear
and David, quite logically, had become the spokesman
for the philosophic artist:

> The artist should be a philosopher. The genius
> of the arts must have no other guide than the
> torch of reason.[37]

D'Angiviller and Diderot had been among the
first to recognize the propaganda potential of art,
the former with his expressed view that it might
"reawaken virtue and patriotic sentiment."[38] Where

the history painting of the old regime had been
considered "an emanation of the throne,"[39] it was
now the duty of those artists serving the new
Republic to provide works of art which would stimu-
late the high moral standards and sense of patriotic
self-sacrifice consonant with an utopian state.

To do this it was necessary to create an
official artistic language. That the neoclassicism
so prevalent from the 'sixties on provided the basis
for such a language is clear, although neoclassic or
antique subjects were not automatically suitable.
A large number of the works produced during this
period though mythological in character were non-
moralizing and therefore not wholly acceptable. What
was needed was a fusing of form and content at once
virile, real and comprehensible to the masses. If
art was to become, in David's words, a "torch of
reason," artists would have to create works which
would reflect the events and ideology of their own
time as well as those events which presented parallel
moments from ancient history.

David, the painter of Brutus, was to become the

Brutus of an aesthetic revolution. His pronounced
distaste for the Academy, its hierarchical organi-
zation, its domination of the salons and virtual
deathgrip on the arts, allied him with the reformers.
In 1787, David had failed to win a desired appoint-
ment as Director of the French Academy at Rome. He
held the conservative elements in the Academy[40]
responsible.

In a letter dated September 17, 1789,[41] David
complained "the Academy no longer likes the antique."
Shortly **before he had** authored a pamphlet, Voeu des
artistes[42] in which he publicly condemned those officials
of the Academy whom he resented and in which he took
occasion to underline the duties of a republican artist.
The pamphlet called for posthumous admission to the
Academy of David's pupil, Drouais, demanded the ex-
clusion of professors' protegees from the special
classes reserved for medal winners and requested per-
mission to sketch directly from classical models.
The essay, which was hailed by a revolutionary jour-
nalist as the work of a "good citizen,"[43] represented
the initial, important assault on the Academy,

In his criticism of the Academy, David was
attacking an institution which could be viewed justi-
fiably as the old regime in microcosm in that its
membership and structure paralleled that of the Estates
General previous to 1789. Founded in 1648 through the
efforts of Le Brun, the Royal Academy of Painting and
Sculpture opened its ranks, at least theoretically,
to all artists of merit--men and women as well. This
seemingly liberal policy was actually a facade for a
rigidly consolidated, exclusive institution. In the
eighteenth century, the academy's membership of sixty
comprised three classes: officiers, académiciens and
agréés. All important decisions including the control
of official policy was vested in the first class. The
académiciens had a limited voice and some voting rights,
but the agréés had virtually no power or importance
other than that of membership which enabled them to
participate in the salons.

It should be remembered that only members of the
Academy could exhibit or be eligible for government
prizes and commissions. The former point is important
when one realizes that by 1787, the Academy had succeeded

in suppressing even those few exhibitions organized by non-members.[44]

David quickly found allies in his struggle for academic reform. Twenty académiciens joined him on December 5, 1789 and presented a demand for democratic revision of the statutes, reform of the previously cited old aristocratic abuses and adoption of a constitution fraternelle.[45] On January 30, 1790 these same académiciens presented their plan for reform and also called for the inclusion of all three classes in the academic deliberations. This plan was quickly rejected and an argument ensued which lasted through April of 1790.

For David and for the Academy, the year was to prove almost more significant politically than artistically. Early in the year, David's radical political inclinations were indicated by his joining the Jacobin Club,[46] and on June 28th when he officially resumed his attacks on the Academy, the tone of his criticism became more violent than before. As both homme politique and artist he led a deputation of his colleagues and addressed the Constituent Assembly. His speech emphasized

the following points: 1) the importance of the arts
to the Revolution as a means of inculcating civic
virtue; 2) the incompatibility of the old Academy
with the new spirit of reason and the constitution;
3) the need to create a new and more appropriate
artistic milieu through the establishment of a commune
des arts.[47] David's address was well received and
was printed and distributed publicly by order of the
Assembly's president, Michel Le Peletier de St. Fargeau.
Copies of it and of the petitions supporting its claims
and demands were sent to the King and to eleven Paris
newspapers.[48]

As a result of David's address the Academy was
generally and officially denounced by the Assembly as
an artistic despotism. That body further ordered the
Academy to revise its statutes so that it might conform
to the spirit of the new constitution.

A majority of the Academy's voting members
created a new set of regulations which acknowledged
David's earlier call for pedagogical reform but did
not embody the active inclusion of the agréés in the
formulation of academic policies. These regulations

were presented to the Assembly on September 21, 1790.

Scarcely a week later, one of David's more immediate demands was answered by the creation of the Commune of the Arts on September 27, 1790. From its founding one of the avowed purposes of the Commune was to speed the dissolution of the Academy, its class system, privileges and control of the salons. The Commune's membership of three hundred artists mounted strong attacks which produced results. On November 8, 1791,[49] the agréés were finally accorded full status while on August 21 of that year, the National Assembly responded to continuous demands of the Commune and declared the salons officially open to all.[50] It was also primarily due to the constant propagandizing efforts of the Commune and the political efforts of David who became a delegate of the National Convention on September 17, 1792, that the Academy was finally dissolved by official decree (August 8, 1793). Its functions, which in the previous two years, had been drastically reduced in number and importance were assumed by the Commune. The salon which met later that month therefore bore the imprint of the newly

recognized body.

Two important aspects of David's attack on
the Academy had been the criticism of its methods
of instruction and the notion that both the instruction
and its end products should be useful to the state.
Some of David's views in these areas had grown out
of his association with the homme de belles lettres
and sometimes architect, Quatremère de Quincy.
Quatremère had been David's close companion during
his Italian years as Prix de Rome winner and again
in 1784. Upon his return to Paris, Quatremère had
been employed as a contributor in architecture to
Panckoucke's Encyclopédie Méthodique. In 1791, he
became involved in a project to erect a colossal
elephant fountain in the Egyptian style on the Place
de la Bastille. That year, he also published the
Considérations sur les Arts du dessin en France suivies
d'un plan d'Académie ou de l'école publique et d'un
système d'encouragemens which was quickly followed
by a Seconde Suite aux considérations sur les arts du
dessin: ou projet de réglemens pour l'école publique
du dessin; et de l'emplacement convénable à l'institut

nationale des sciences, belles lettres et arts. As
their titles indicate, the two works are schemes for
the creation of a state system of public instruction
in the arts. Also included was a plan for govern-
mental encouragement of the arts through the awarding
of commissions and prizes and a project for the complete
renovation of the Academy and establishment of modern,
more truly national institutions encompassing not only
the arts but literature and science as well.

Quatremère further echoed the view of the
philosophes that the reign of liberty and reason
should bring about a new and favorable period of
artistic achievement and should affect contemporary
morality in much the same way that it had produced
a high degree of personal and civic virtue and a high
level of artistic achievement in Greece and Rome. For
Quatremère as for David the concept of identifying the
fine arts with the revolution grew from an essentially
moral rather than aesthetic preoccupation. Quatremère's
concern with the relationship between the arts and
society or what he called the "destination publique"
of art is summarized in this statement:

> The correlation of the art of painting with
> the needs of society, that is the first and
> foremost moral function of the arts.[51]

Moreover, artistic figures like David and Quatremère

participated directly in the political machinery that

effected the necessary changes in French society.

They were not merely artists going along with the

various ideas or programs of the moment but the products

of an enlightened generation which hoped to reform the

arts, institutions and moral standards of their day.

As such, they were not only the representatives of the

new philosophic spirit in art, but the shapers of a

new order founded on a secular ideal. Their disdain

for the artistic institutions, educational practices

and probably for the art of the old regime cannot be

divorced from this philosophic and political context.

Thus in their pronouncements and in David's history

paintings of the period there is an absolute identi-

fication of form and content with the Revolution.

Subject matter was not enough, nor was style. What

was required and attempted between 1789 and 1794 was

a total integration of art and governmental policy.

The problems encountered in this integration were

numerous and complex, and not the least of them was
the major obstacle of creating a new religion to suit
an established vocabulary of classical forms and
themes.

CHAPTER IV

No one ought to be disturbed on
account of his opinions, even reli-
gious, provided their manifestation
does not disturb the public order
established by law.[1]

The civil reforms instituted during the first

years of the Revolution were complemented by government

attempts to reform the established religion. To the

delegates to the Constituent Assembly as to most of

the philosophes who had campaigned for ecclesiastical

reform, the notion of separation of church and state

would have seemed indeed strange. And while the

philosophes often were anti-clerical in their writings

and attitudes they were not uniformly anti-religious.

Montesquieu had expressed the hope that Catholicism

might come to terms with reason, and Voltaire, unlike

d'Holbach who wished to see the state assimilate the

functions of religion, speculated that Catholicism

might, under government supervision, be an instrument

for moral good and social order.[2] From the beginning,

the men of 1789 seemed clearly bent on effectively

nationalizing the church and incorporating it into
the new governmental and social structure. Like the
Abbé Raynal, many felt that "The state...is not made
for religion, but religion is made for the state..."
and thus that the state had the right "...to pro-
scribe the established religion, to adopt a new one
or even dispense with religion altogether...(since)
the state is supreme in everything..."[3]

Initial calls for reform had been sounded within
the ranks of the clergy and are reflected in the cahiers
or lists of grievances drawn up by the lower clergy
which agreed that a renovation of the Gallican church
was necessary. In the spirit, if not in the letter
of the law, the government's religious measure,
especially those affecting financial matters, were
initially supported by the religious members of the
third estate. However, the refusal of the deputies
to agree to the clergy's demands to make Catholicism
the state religion created considerable disenchantment.[4]
Even so, there was no accelerated protest even in the
face of the decree of February 13, 1790 which forbade
the creation of new monastic orders and abolished

recruitment in existing orders.

An ecclesiastical committee appointed by the
Assembly in August of 1789 submitted in April 1790
a plan for the reform of the organization and functions
of the clergy. The majority of members in this committee
believed in the independent nature of the Gallican or
national French church. They stressed union with
Rome but not subservience to Rome, and believed that
religious reforms might be enacted without Papal con-
sultation. The plan they submitted was lengthily
discussed in the Assembly and became the law of the
land on July 12, 1790. Called the Civil Constitution
of the Clergy, a name which suggested that the measures
were more concerned with religious functions than with
dogma, the decree which effectively liberated the
church from Papal authority insisted upon its partici-
pation in the Revolution.

In subordinating the church to the state and in
converting religious functionaries to civil functionaries,
the delegates of the Assembly were following the pre-
cepts of philosophes like Raynal and Rousseau. In the
Contrat Social,[5] Rousseau had criticized Christianity

for its dedication to the thought of Heaven and its
lack of preoccupation with the temporal world. He
had moreoever equated civil and theological morality
and proposed "...a purely civil profession of faith,
the articles of which it behooves the Sovereign to
fix...treating them as a body of social sentiments
without which no man can be either a good citizen
or a faithful subject."[6] He further stated "The dogmas
of this civil religion should be few, clear and enun-
ciated precisely...The positive clauses are: the
existence of a powerful, intelligent, beneficent and
bountiful God; the reality of the life to come; the
reward of the just, and the punishment of evildoers;
the sanctity of the Social Contract and of the Laws."[7]

The athiest, d'Holbach was even more explicit:
"The function of the state is to make good men; the
function of religion is to make good citizens."[8] For
the revolutionary leader, Mirabeau who believed that
the notion of a successful revolution depended on
de-catholicizing France "...the service of the altar
[was] the public function."[9]

The delegates to the Assembly had not predicted

the negative reception of the Civil Constitution of the Clergy. Yet the religious were not about to accept their new independence from Rome only to exchange it for dependence on the Assembly. Those ecclesiastics who were delegates abstained from voting on the Civil Constitution. One of them, the Archbishop of Aix,[10] stated that the measure would not be considered binding until it had received "canonical consecration," but the Assembly refused to allow a canonical council to be organized.

The constitutional character of the measure did not allow the King to veto it and his only alternatives were to accept or reject it. Thus, in an effort to maintain some semblance of popularity, Louis XVI ratified the decree and it was published on July 22, 1790. At the same time, the King appealed to Pope Pius VI for his consecration. After months of delay, it became clear that the Pope would never accept the document and was in fact unalterably opposed to the Revolution.

In order to force more effective compliance with the decree the Assembly introduced stronger

measures. It decreed on November 27, 1790 that
all functioning ecclesiastics would be required to
take an oath of allegiance to the uncompleted consti-
tution which meant commitment to the Civil Constitu-
tion. All those who refused to take the oath risked
loss of office and non-juring priests were liable to
prosecution and imprisonment.

A pattern of resistance and even open hostility
followed for the next nine months. Though Louis XVI
had given reluctant sanction to the decree on the
clerical oath, he clearly indicated that he opposed
the measure and therefore only about 50 per cent of
the clergy became loyal "government priests" by taking
the oath. Moreover, the denunciation by Pius VI in
March and April, 1791 of the Revolution and all its
religious measures gave impetus to further anti-
revolutionary sentiment among the clergy. Instead
of creating a truly national church whose organization
would reflect the reforming spirit of the Revolution,
the Assembly had created two bodies: one with adherents
to the revolutionary government and one with adherents
to the old regime.

Confusion seized the dislocated Church. Dismissed
clerics continued to function secretly. Though govern-
ment priest's services were sought in official matters--
baptisms, marriages, burials--they were frequently held
in contempt by their parishioners while non-juring priests
became local martyrs.[11] In an effort to eradicate
sympathy for these "traitorous" clerics, and to insure
the installation of government priests, the revolutionary
clubs and even the National Guard were called in for
security. In many instances, non-juring priests were
attacked by club members or by juring priests as they
celebrated mass in private chapels.[12] This further
exacerbated already existing antagonisms within the
clerical ranks. It gradually transformed what was
originally an opposition based on religious grounds
into an opposition to the Revolution itself. By June,
1791, government officials in Brittany could write with
only small exaggeration: "The confessionals (of the
non-juring clergy) are schools where rebellion is
taught..."[13]

In December, 1791, non-juring priests were given
a week's time to take the oath to the new constitution.

On refusal, they were immediately placed under
official surveillance. By May, 1792, owing to
the worsened economic conditions occasioned by the
war with Austria and Prussia, the threat of invasion
and serious food shortages, an effective state of
emergency was declared and the non-juring priests
were declared subject to immediate deportation as
enemies of the state.

After the abortive attempt of the King and
Queen to flee the country,[14] the masses of Paris
became more undisciplined. The night of August 10
was to become memorable in revolutionary history, not
only as the date on which the defenders and many of
the inhabitants of the Tuileries were murdered, but
especially as an evening of violently anti-religious
activity.[15]

On the 20th of September, 1792, the Assembly
authorized divorce which meant that it had assumed
the function of formulating church dogma. Shortly
thereafter,[16] it authorized the confiscation of all
metal furnishings in churches so that they might be
melted down and forged into cannons or money. The

Assembly also prohibited the wearing of eccesiatical

robes except during religious functions and proscribed

open air religious processions and ceremonials.[17]

A decree published on October 10, 1793 concisely

summarizes the prevailing official attitude toward reli-

gion and religious images:

Considering that the French people cannot recognize
any official symbols except those of the law, of
justice and of liberty nor any worship except that
of universal morality; nor any dogma except that of
its own sovereignty and supreme power...it is
ordained that 1) no forms of religious worshop
should be practised except within their respective
temples, 2) ...all religious symbols found on high
roads, parades and other public localities shall be
demolished, 3) no obsequies at funerals or on grave-
stones, only the inscription "Death is eternal sleep."[18]

As the government attack on Christianity sharpened

with the abolition of the Constitutional monarchy, there

was an increased preoccupation with destroying or obvi-

ating the outward manifestations of the former state

religion.

In 1765, the author of the article "Peinture" in

Volume XIII of the Encyclopédie ou dictionnaire raisoné

des sciences, des arts et des métiers (Paris 1751-1765)

had maintained:

> The governors of men have always made use
> of painting and sculpture in order to in-
> spire in their subjects the religious or
> political sentiments they desire them to
> hold.[19]

Quatremère de Quincy had further observed, in 1791:

> Under tyranny, the arts turned people from
> their true interests and caressed them to
> sleep, but place the arts in the hands of
> the people, and they will become the flail
> of tyrants. The arts are only instruments
> which will produce good or evil depending
> on the hand that uses them.[20]

From 1791 onwards, royal and religious emblems
and images were systematically destroyed. Having con-
demned the political, social and religious institutions
of the old regime, the more dedicated partisans of the
Revolution set out to eradicate the symbols of the old
order. As early as September, 1789, the journal,
Révolutions de Paris, had maintained:

> The statues of Kings in our cities are not
> the work of the people...the recent events
> in the districts have doubtless impressed
> themselves upon everyone's memory, but time
> will soon efface those memories...for those
> who cannot read, it will be as though the
> names and ceremonies never existed. We
> should speak to the people of their glory
> by means of a public monument, for we must
> never forget in this revolution the powerful
> language of symbols....If it is objected that
> such a statue is too costly, let us take the
> marble and bronze from the statues erected to

the iniquitious Louis XIII...from the debris
of this monument we may raise one to the
defenders of the fatherland..."[21]

In his <u>Salon</u> of 1765, Diderot had written:

My friend, if we love truth more than the
fine arts, let us pray God for some icono-
clasts.[22]

His prayers were answered between 1790 and 1794. Early

in 1790, a group of artists petitioned the National

Assembly to request that the King "order the destruction

of all monuments created during the feudal regime."[23]

During the initial stages of the government campaign

against the old church, little actual destructiveness

was expressed, but with the advent of increasingly

harsh measures, violence became the order of the day.

Murder and pillaging had marked the uprisings of

August and October, 1792, and the churches and their

ministers were among the major targets of mob violence.[24]

Among the most effective forces in the promotion of

revolutionary iconoclasm were the Jacobin clubs. Not

only does the following passage from a diary of Jacobin

meetings document their encouragement of the destruction

of Christian art, but it suggests a program of sig-

nificant artistic substitution:

> Destroy these signs of slavery and idolatry
> which only serve to perpetuate ignorance
> and superstition. Replace them with images
> of Rousseau, Franklin and all the other
> great men, ancient and modern, which will
> fill the people with a noble enthusiasm
> for liberty.[25]

Between 1791 and 1794, numerous works of art were either wantonly or calculatedly destroyed. Major public monuments like the statues of Louis XIV in the Place Vendome and Henri IV on the Pont Neuf were the targets for the attack, but the churches were especially vulnerable. By August 10, 1793, government sanctioned public demonstrations like the <u>Festival of Unity and Indivisibility</u>[26] (Plate XII) often featured bonfires to which painted or carved representations of artistocratic or religious subjects were consigned.

Having committed themselves to a program of artistic encouragement on the one hand and artistic destruction on the other, the mentors of the Revolution were faced with a decision. If the religious and secular art of the old regime could not be forged into a sword of the Revolution and if, at the same time, it was against the nation's interest to allow careless destruction, it was necessary to create a

body which would survey the extant works of art and
designate those which were worthy of preservation.
A Commission of Monuments was created in November,
1790[27] and David was one of its original members.
This body, which functioned partially as an artistic
police force and partially as a receiving house for
suggestions regarding government commissions was
superseded by a second body, the Commission of the
Arts[28] which enjoyed power and prestige from 1793 to
1796. The Commission of Monuments had been founded
to preserve "manuscripts, charters, monuments of
antiquity, statues, paintings..."[29] However, it never
operated with any real efficiency and in any event its
functions were incomplete. What was clearly needed
was a complimentary body. Thus the Commission of the
Museums was organized through the efforts of Roland[30]
in 1792 and was charged with the creation of a national,
public museum. The idea for such a museum can be traced
as far back as 1747 when the critic, La Font de St.-Yenne
called for a public museum as a means of raising the
level of contemporary art.[31] The Commission of the
Museums was periodically attacked by David, partially

because of its conservative membership and partially
because it was hardly more active than the Commission
on Monuments. As a result, a Conservatory, consisting
of a number of David's followers, assumed the
Commission of the Museums' functions on January 16,
1794. Echoing David's neoclassic line, the members
of the Conservatory spoke of "expurgating" and "regen-
erating" French art. It was largely their deliberations
however which selected the objects eventually destined
for public exhibition.

The sporadic work of the various commissions
bore fruit. In August, 1793 a national museum of
French monuments was organized in the Louvre and
opened to the public. Thus the revolutionary govern-
ment and its artistic policy-makers were able to
neutralize the symbolic value of the old art. By
removing the signs of royalty and the old religion
from the active, public sphere they caused them to
lose their didactic, official power and become objects
to be viewed or admired in and of themselves.

The initial destruction and subsequent neutraliz-
ing of the old art was merely an outgrowth of a larger,

ideological attack in which the revolutionary govern-
ment pitted its own new dogma against that of the
established church. Certainly, if the government
attempts to reform the church had been confined to
organization and finance, they would not have produced
the strong negative reaction which took place in 1791,
1792 and after. But precisely because the reforms were
not merely administrative but also concerned matters
of dogma, they were doomed to violent opposition.
Since Catholicism could not be relegated to a museum,
it had to be suppressed and a substitute faith was
required.

In the twenty or thirty years preceding the
Revolution, an intellectual resistance to organized
Christianity and especially to Catholicism flourished.
But it was not really until the Church rejected the
Civil Constitution of the Clergy, that the idea of a
complete rupture with the church and its replacement
by a more suitable and accomodating cult gained popu-
larity.

The groundwork for such a cult had been laid
in the many speculations of the philosophes. From

the various schemes to elevate mankind and create
truly worthy and responsible members of a virtuous
republic, a number were especially important.[32] Of
these, the most compelling was certainly Rousseau's
image of an ancient city, sovereign in every sense
of the word, guardian of the citizen's virtue and
the instrument of his happiness as well.

From 1791 onwards there was a further prolifer-
ation of patriotic "cathechisms" and manuals of good
citizenship. The popular revolutionary journals such
as the Chronique de Paris and Révolutions de Paris
reflect the official concern with providing a viable
alternative to Catholicism.[32a] Among the political
clubs there was great support for the establishment
of a purely civic cult, similar in its general nature
to the "profession of civic faith" described in
Rousseau's Contrat Social. Both the Girondins and
the Jacobins, as the most powerful political factions,
supported adoption of this new faith. The latter
approached the task of disseminating the new faith
with an almost evangelical ardor. Throughout the
country they distributed copies of the new constitution,

the Declaration of Rights of Man (which had been
called the national catechism), the popular tract,
Almanach du Père Gérard (a vicious, anti-Catholic
polemic) and a spate of crude, anti-clerical cartoons.
(Plates XIII, XIV, XV)

The governmental measures against the church,
the attacks of revolutionary periodicals like the
Révolutions de Paris, Père Duchène and Ami du Peuple
were complemented by a program of active encouragement
of secular faiths. Numerous philosophes had advanced
projects for secular faiths which would be consonant
with the reign of reason and liberty. It remained for
these projects to be implemented and this implemen-
tation was one of the tasks of the Committee of Public
Instruction. From 1791 this body had been charged with
the task of propagandizing the revolution and incul-
cating its message. It became the agency responsible
for the direction of all civic demonstrations and
festivals, and it was largely through the agitation
of the Committee of Public Instruction that the so-called
republican era was established in October, 1793 and that
a new official calender replacing the old Christian

designations was adopted by the new regime (Plate XVI).

In November, 1793 the Convention heard an address made

by M. J. Chenier in the name of the Committee of Public

Instruction which proposed that a virtually defunct

Catholicism be replaced by an official religion of

reason and love of the Fatherland.

> Wrench the sons of the Republic from the yoke of
> theocracy...then, freed from prejudice and worthy
> to represent the French nation, you will be able,
> on the ruins of the fallen superstition, to found
> one universal religion, which has neither secrets
> nor mysteries, whose one dogma is equality, whose
> orators are the laws, whose pontiffs are the magis-
> trates, which asks no incense from the great human
> family to burn save before the altar of our country,
> our mother and our deity.33

As the government had forbidden the holding of

public services, processions and indeed any outward

Christian religious manifestations, it nevertheless

recognized that these customs filled a need and that

they might be utilized for the inculcation of a desir-

able civic religion. The collected works of Mirabeau

contained a sketch for a·treatise on "public, civil

and military festivals," as did the works of J. J.

Rousseau. The most direct sources of inspiration for

the creation of the revolutionary fêtes philosophiques

et civiques was Rousseau's Lettre à d'Alembert sur les

spectacles (1758). The following passage from this work

was often cited during the revolution:

> What! Must there be no spectacles in a Republic?
> On the contrary, there must be many. It is in
> the Republic that they are born, it is in its
> bosom that one sees them sparkle with a veritable
> air of fête.... It is in the open air, it is
> beneath the sky that you must assemble to give
> yourself up to the sweet sentiments of your
> happiness.... But what will be demonstrated
> there...?[35]

The answer to that last question was to constitute a

great part of the revolutionary ideology and its icono-

graphy. The content and timing of the revolutionary

fêtes was never left to accident. The ancient festi-

vals were too well admired to be ignored by the revolu-

tionary artists who sought models for their contemporary

equivalents. These represented a civic panorama com-

parable to those of the golden age (in Greece) which

was as valid to the revolutionaries as their own time.

In the 1780's, the paintings of David had provided

moral sermons which were quickly understood by even

the untutored. The civic festivals presented the oppor-

tunity to transform the antique tableaux into a vital,

significant experience. Instead of merely looking at

paintings which made them feel a bond of kinship with

Greeks and Romans, the revolutionary generation became

Greeks and Romans:

> This remembrance was devised by our ancestors, the
> inimitable Greeks and Romans who knew how to honor
> wisdom and who gave us the examples, the models of
> all that we see of beauty today.... [36]

The content of the numerous festivals of the

revolution was varied, but can be divided as follows:

1) those which marked the various stages of the Revo-

lution, 2) those which celebrated the progress of

reason, 3) those which honored the fatherland, and

4) those which honored the great prophets and martyrs

of the revolution.

Initially, those festivals which marked revo-

lutionary progress combined elements of the old

Catholic ceremonial with neoclassical props gleaned

from contemporary painting or contemporary archaeo-

logical publications. [37] On the occasion of the first

of the major revolutionary festivals, that of the

Federation (July 14, 1790) (Plates XVII and XVIII)

which commemorated the taking of the Bastille, a

mass was said, the banners of the National Guard were

blessed and the entire National Assembly proceeded

to the Champ de Mars to take an oath of allegiance to
the new government. This oath was administered at an
outdoor, secular altar called on and after that occa-
sion, Autel de la patrie. Both the initial ceremony,
which was described by the poet André Chénier as,
"one of the most imposing and august ceremonies ever
conducted by a free people,..." and the autel were to
serve as points of departure for countless successive
rites. The autels were erected all over the country.
One of the earliest of these altars was erected in
1790 by a certain Cadet de Vaux on his estate in
Franconville - la - Garonne. According to a contem-
porary description, the altar was placed on a hill and
its exterior bore replicas of the Roman fasces, a
pike and a Phrygian cap; it carried an inscription
from Voltaire's play, Brutus.[39]

As the revolutionary measures against the church
became more stringent, the altars of confiscated
churches were transformed into autels de la patrie
while the churches became temples of liberty or reason,
or else were given to local political clubs.

The second of the official national festivals

occurred on August 10, 1793 and was designated as the
Festival of the Unity and Indivsibility of the Republic
or Festival of Regeneration. It was two-fold, on the
one hand it served to honor the constitution, the over-
throw of the monarchy, and the cause of national unity,
and on the other, it was designed to complement the
growing emphasis on Nature.

Like the first festival, the program was conceived
by the major artists in government favor headed by David.
The latter presented a report to the Convention on July
11, 1793 which included a description of the make-up of
various participating groups, the order of march and
some sketches of costumes and props.[40] David requested
and received the sum of 1,200,000 livres for the expense
of mounting the festival. His final instructions appeared
in Paris newspapers the day before the festival:

> All Frenchmen who wish to celebrate the Festival
> of unity and Indivisibility...should rise before
> dawn, so that the touching scene of the gather-
> ing be illumined by the sun's first rays...be
> for them the symbol of Truth to which they would
> address their songs of praise.[41]

The fête which was celebrated in an atmosphere of violent
internal unrest, factional rivalry and fear of foreign

invasion, took place on the site of the old Bastille.

Delegates from the Convention, representatives of the

departments, local assemblies and mobs of Parisians

gathered in front of a colossal statue of the goddess

of Nature from whose breasts flowed "waters of regenera-

tion"(Plate XIX). Contemporary engravings, and the sur-

viving five _decimes_ piece from the year II, illustrate

the antique character of the rite. There were five

stages or stations to the ceremonial. The first has

already been described, the second was a triumphal arch

on the Boulevard Poissoniere (Plate XX), the third, a

huge statue of the goddess of Liberty erected on the

pedestal of the former statue of Louis XV in the Place

de la Revolution where, according to a custom previously

described, royal symbols and emblems were burned. At

the Place des Invalides there was a giant statue person-

ifying the French people (Plate XXI) and at the last

station, an Altar of the Fatherland erected on the Champ

de Mars, the entire group swore an oath to the Constitu-

tion and like the _Horatii_, vowed to defend it to the

death (Plate XXII).

Two months after the celebration of the _Festival_

of Unity, the revolutionary calendar was adopted and the
old common references to saint's days and other Christian
ceremonies disappeared. In the same month, the Commune
of Paris, under the influence of the procurer general
Chaumette, declared support of the cult of Reason.[42]
Once more, David, who had directed the second fete, was
called upon to organize a pageant celebrating the faith
in Reason. The artist seems to have been assisted by
the dramatist, M. J. Chénier, spokesman for the
Committee of Public Instruction who had made an address
on November, 1793, quoted earlier.

The Convention blessed the scheme and it became
an official ceremonial scheduled for the 20th of Brumaire
of the year II (November 10, 1793). The rite was cele-
brated in the former cathedral of Paris which became for
the occasion a Temple of Reason. Before the main portal
whose religious sculptures had been removed were placed
busts of the principle philosophes, Voltaire, Rousseau,
and in this instance, Benjamin Franklin. Inside the
church, the emblems of superstition having been taken
away or covered, there was a huge mountain composed of

artificial rocks. An antique temple, growing from the
mountain site, bore the inscription "to philosophy."
(Plate XXIII). On a circular altar, a "torch of truth"
with tricolored sashes descended from the mountain and
took the flame. At this moment, Reason personified as
a young woman with a red Phrygian cap, blue cape and
white dress, ran from the temple while the congregation
arose and singers intoned a Hymne à la liberté, com-
posed for the occasion by M. J. Chénier and F. Gossec:

> Descend, O'Liberty! Daughter of nature,
> The people has recovered immortal power:
> On the pompous debris of the false old religion,
> Its hands will erect your altar.43

When the song was completed, the congregation extended
arms to the goddess who was portrayed by a celebrated
actress, Mlle. Maillard. She returned their gesture
with a look of benevolence and protection and re-entered
the temple whereupon the entire group proceeded to the
Convention where the President heaped accolades on the
goddess and officially designated the "former church of
Notre Dame" as a Temple of Reason.

The marked atheism of the cult of Reason did not

meet with unanimous approval. Some political leaders,

of whom Maximilien Robespierre was the most vigorous

representative, voiced strong objection to the atheis-

tic nature of the belief. In a speech made to the Jaco-

bin club on November 20, 1793, Robespierre observed:

> ...there are men who attempt to make a religion of
> atheism. Everyone is free to think as he pleases
> on that matter, but for a public legislature to
> adopt it as a system would be...senseless.... The
> Convention abhors such an idea. Atheism is aristo-
> cratic. The idea of a great being who watches over
> oppressed innocence and punishes...wickedness is
> altogether popular. If God did not exist it would
> be necessary to invent him.[44]

On the 18th of Floréal of the year III (May 8, 1794),

the all powerful Robespierre stated his belief that

religious and moral ideas must reflect republican princi-

ples. He indicated, as he had in his previous discourse,

that he felt the atheistic spirit to be incompatible with

civic duty and moral consciousness and further stated

that it was in the interest of the Revolution to recon-

struct society upon a firm basis of belief in a Supreme

Being and in the immortality of the soul. Though some-

what Rousseauian in general flavour, this view rejected

a great body of philosophic writing on the subject of

religious liberty. "...the true priest of the Supreme
Being is nature; his temple, the universe, his worship,
virtue."[45]

As easily as it had acclaimed the worship of Rea-
son six months earlier, the Convention proclaimed on
May 7, 1794:

> ...that the French people recognize the existence
> of the Supreme Being and the immortality of the
> soul...a series of festivals should be instituted
> in order to recall men to the thought of God and
> to the dignity of their nature...[46]

Again the Committee of Public Instruction pro-
vided the necessary funds for a national celebration
and David was once more chosen as the artistic super-
visor of costumes, settings and the numerous props.
The Festival of the Supreme Being was held on June 8,
1794 and is regarded by many as the most magnificent
of the revolutionary spectacles. The Moniteur of
June 13, 1794 described the principle moments of the
ceremony in considerable detail, though numerous other
contemporary sources carry lengthy paragraphs on the
temporary stands, monuments and fountains erected under
David's supervision.

In the Tuileries Gardens, a large crowd gathered

and were met by the members of the Convention headed
by their president, Robespierre. From a platform, the
president preached a sermon and then taking a torch of
Reason presented by David, he set fire to a cardboard
statue of Atheism. From the smoky debris of that
statue, a personification of Wisdom emerged and pointed
in the direction of the Champ de Mars. The procession
of delegates, section members and the populace moved
along to the Champ where a huge symbolic mountain had
been constructed (Plate XXIV). Robespierre and the
other convention members stood at the mountain's summit
while the chorus sang Gossec's hymn:

> Father of the Universe, Supreme Intelligence,
> Unknown benefactor of blind mortals;
> You reveal yourself to the gratitude
> Of those who erect your altars.
>
> Your temple is on the mountain tops,
> in the air, on the waves.
> You have no past, you have no future.
> And without inhabiting them, you fill all the worlds
> Which are not able to contain you....47

Finally, in what was possibly the most stirring moment,
youths and old men re-enacted the rite depicted in
David's Oath of the Horatii.[48]

The role of the festivals as a popular art related
to the painting, sculpture and architecture of the period

cannot be underestimated. On the sixth of January,

1794, the Convention proclaimed:

The celebration of festivals is one of the most
important things presented to you since the
Revolution's inception....[49]

The philosophes had recognized the vital function that

the festivals could play in government, and the educa-

tional programs of the Committee of Public Instruction

reveal that this body acknowledged them as a very basic

tool of social control. That they "formed Republicans"

in M. J. Chénier's words cannot be disputed. Even after

the liquidation of Robespierre and subsequent imprison-

ment of David, the surviving leaders remained convinced

of the effectiveness of the festival as a propagandizing

weapon and they were retained until the advent of

Napoleon Bonaparte.

We are brought then to the conclusion that there
is nothing more important than the national festi-
vals. For they furnish us eith the best means to
preserve these for them; to establish and purify
the national customs; to give birth to and to rein-
force for them that powerful, active and fruitful
enthusiasm for the laws of the Fatherland, liberty,
equality and for all the principles which lay the
foundation for the common honor and for the happi-
ness of all.50

The festivals took the furnishings and props

of antiquity and put them in the hands of the people.

Paris and various provincial cities were transformed

into giant stages on which were erected the ephemeral

arches, temples, altars and statues. The streets

became via sacrae et triumphalis for the numerous

chariots and funeral carts and for the antique-garbed

citizens. In the festivals devoted to the cults of

reason and the Fatherland a definite pattern of repre-

sentation and consistant symbolism evolved. The icono-

graphy of this new revolutionary faith was as explicit

as that of the old religion. The use of the fasces,

pike, Phrygian cap, and Jacobin mountain has already

been discussed. The reference to philosophers, ancient

and modern in the festival ceremonial was also a major

feature of this iconography. As the revolution pro-

gressed, it naturally claimed heroes and martyrs. Among

the former were the first delegates to the Legislative

Assembly, the latter-day Roman senators whose images

soon adorned the interiors of political clubs (Plate XXV),

and ultimately, the homes of the middle and lower class

elements they represented. There were local patriots

and there were those whose actions in behalf of the

Revolution entitled them to national distinction.

Such a man was Mirabeau, one of the early mentors of the constitutional monarchy and a representative of the older enlightenment generation. The news of his death in April of 1791 had created an aura of national disaster. The government decreed that a state funeral should be accorded the former leader and it designated the church of St. Genevieve as his final resting place.

All of the deputies to the National Assembly, government ministers, local administrators, military aides, delegates from the political clubs, fraternal societies and representatives of the various classes made up a funeral cortege whose procession, speeches and singing lasted for approximately seven hours.[51]

Mirabeau's funeral served as a dress rehearsal for an even more elaborate public ceremony, the transportation of the remains of Voltaire from the Abbey of Our Lady of Scellieres to the church of Saint Genevieve. On May 30, 1791, the National Assembly declared that Voltaire was worthy of receiving the honors that the Fatherland reserved for great men.[52]

After a number of postponements, owing primarily

to growing resistance to the government's religious
reforms, the "glorification" of Voltaire finally took
place on July 11, 1791. The organization of the cere-
monies, design of costumes, props, etc., was shared by
David, the sculptor, Moitte, and Roland, the mayor of
Paris. According to Voltaire's nephew, the Marquis de
Villette,[53] the purpose of the organizers was to "emu-
late the pomp and grandeur of the Greek apotheoses and
Roman consecrations." Thus, the costumes and musical
instruments employed in the ceremony were modeled after
designs made by David which were based in turn on the
artist's carefree copying of ancient monuments during
his visits to Rome (Plates XXVI and XXVII).

Again, as in the funeral of Mirabeau and the
various national festivals described earlier, there
was a clear demarcation of the many participating groups:
National Guard, Jacobins, workers of the Faubourg St.
Antoine, the wreckers of the Bastille, deputies from
the sections, members of the National Assembly, school
children and representatives from the theaters. While
the various participants carried emblems with revolu-
tionary slogans, images of Rousseau, Franklin

and Mirabeau, the theater group marching in front
of a replica of Houdon's statue of Voltaire, car-
ried banners with inscriptions from the philosophe's
plays. The following was among the most popular
verses represented:

> I am the son of Brutus, and I carry engraved in
> my heart liberty and a horror of kings.

<div align="right">(Brutus, Act II, scene 2.)</div>

Probably the most striking feature of the pro-
cession was a huge antique chariot, designed by David,
the appearance of which survives through contemporary
prints.[55] Drawn by white horses and proceeded by Roman-
costumed attendants, this vehicle carried the "sancti-
fied" remains of Voltaire from the Bastille to the
church of St. Geneviève, recently designated as the
Panthéon française. Finally, at approximately ten in
the evening the casket of Voltaire was placed next to
that of Mirabeau. Appropriate summaries of the great
state funeral were given in the Chronique de Paris
(July 12, 1791) which spoke of the wish of the people
"to deify its liberator," the Correspondance Nationale
(July 16, 1791) which characterized the ceremony as

"religious and civic" and Camille Desmoulins' Révo-
lutions de France et de Brabant which pompously declared
"no saint of the old calendar could boast of having made
as brilliant an entrance into heaven as...Saint Voltaire."[56]

The apotheosis of Voltaire, even more than that
of Mirabeau, represented the public triumph of the
secular, revolutionary spirit over the old clerical
influences. It provided the model for subsequent state
funerals which, like the national festivals they comple-
mented, succeeded in filling the gap created by the sup-
pression of the old, established religion. Moreover, it
provided a precedent for the refinement of propaganda
techniques, by identifying the contemporary, revolution-
ary figure with the great heroes of the past. What
followed quite natually in the next few years was a
preoccupation with excellence and virtue that developed
into a veritable cult of great men.

The earlier concern of French writers in the
eighteenth century with greatness, devotion to country
and the search for appropriate recognition of these has
been cited in preceding chapters. But the programs of
the Director General of the King's Buildings, D'Angiviller,

were mainly conceived to honor the great men of France's
past--not her present. And nowhere did D'Angiviller
reveal a concept of sanctification or deification
comparable to the one which developed during the
first years of the Revolution.

Though Voltaire had not been sacrificed for his
country and though the death of Mirabeau was likewise
a natural one, the often violent progress of the
Revolution claimed its inevitable martyrs. Among the
earliest of these was a regiment of Swiss soldiers from
Chateauvieux who were stationed at Nancy and who rebelled
against their "aristocratic officers in 1790."[57] Some
of the soldiers were killed in the crushing of their
rebellion, the rest were sent to the galleys at Brest
as punishment for their insurrection. However, the
image of the liberty loving Swiss turning on their trai-
torous superiors was an appealing one and a suscription
was raised which purchased their freedom. In March, 1792,
a group headed by David, M. J. Chénier, and the Jacobin
delegate, Collot d'Herbois, presented a petition to the
Paris Municipality requesting permission to organize a
celebration in honor of the brave Swiss. The theme of

the celebration, Liberty, was enunciated in the mise
en scène which again included an antique chariot,
covered with reliefs, on whose top a statue of Liberty
was seated.[58] Once more some idea of the specific
nature of the ceremonial pomp and paraphernalia is pro-
vided by a contemporary engraving (Plate XXVIII).

The next great state funeral was the interrment
of Michel Le Peletier de Saint-Fargeau in the Panthéon.
Le Peletier was a Jacobin delegate who had voted for
the death of the king and who was, in turn, assassinated
by a former royal bodyguard on January 20, 1793. Immedi-
ately, the Jacobins hailed their dead comrade as a
"Martyr of Liberty," and called upon David to organize
a ceremony which would convey to the people the idea
that it was not one man who had been attacked, but the
very concept of liberty and popular sovereignty to quote
Chapter I.[59]

"A l'antique," the semi-naked corpse of Le Peletier
was publicly displayed in the Place Vendôme before its
transfer to the Panthéon.[60] After the funeral, David
proposed a marble monument to Le Peletier, to be erected
in the Place Vendôme as a commemoration of the solemn

obsequies celebrated there.[61] Subsequently, he busied
himself with sketches for a canvas to be presented to
the National Convention as a memorial to the fallen hero.

Jean Paul Marat, the journalist and radical deputy
to the Convention, had maintained the nobility of serv-
ing the Fatherland and in particular, that "...glory,
that fruitful source of whatever men have done that is
great or beautiful, was the object of every reward..."[62]
in the republic. Thus it was appropriate that perhaps
the most spendid reward, in the form of a magnificent
state funeral, was accorded the glorious "Ami du Peuple."
Stabbed by the royalist sympathizer, Charlotte Corday,
while seated in his bathtub, the vicious pamphleteer
and critic of the Convention became the most popular
revolutionary martyr of them all. Before the funeral,
Marat's body was exhibited, together with his bathtub
and writing stand, in the former Church of the Cordeliers.
On the evening of July 17, 1793, the body was carried
through the streets of Paris, and finally, it was
buried at midnight in the garden of the Cordeliers.[63]

Like those given to Le Peletier the honours to Marat

did not end with his state funeral. David undertook
sketches for his **Marat Assassinated** shortly after the
discovery of the latter's death, and by November he
had completed his canvas which, like the Le Peletier
painting, was presented to the Convention on November
14, 1793.[63a]

But the funeral of Marat was the last of the
great revolutionary commemorations of individual virtue.
Though there were later attempts to arrange appropriate
ceremonies for the child martyrs, Joseph Barra and
Agricola Viala, these were never realized.[64]

One of the most important and logical outgrowths
of the general wish to reform public morals, through
the institution of festivals, state funerals and a
program of government commissions was the creation of
a living monument which was symbolic of the secular
excellence towards which the Revolution strove.

Quatremere de Quincy, who in 1791, had proposed
a reorganization of artistic and technical instructions,
became a member of the Commune of Paris and later of
the National Assembly.[65] In May of that year, he under-
took a careful study of the church of Ste. Genevieve

which had become a civil building by a decree of April
4, 1791.[66] The purpose of his investigation was to
determine whether the church would be suitable for
transformation into a Panthéon française or final
resting place for the great men of France. His Rapports
sur l'édifice dit de Ste. Geneviève, fait au Directoire
au Département de Paris (1791-1793) indicate the measure
of progress achieved in effecting that transformation.

The concept of creating a temple of glory and
a monument to the great men of the Revolution was cer-
tainly an amalgam of contemporary philosophic and religious
ideas. Quatremère enlisted the services of a number of
artists in drawing up his program for renovation, among
these, the sculptors Moitte, Le Breton, and Le Sueur are
probably the best known. If completed, the so-called
Panthéon would have become a corpus of revolutionary art
and ideology, as well as a tangible testimony to the
rejection of the old religion and its art.

The building had been begun by Jacques Germain
Soufflot in 1755. In 1791 its exterior and interior were
almost aridly classical, reflecting the development of
later eighteenth century ecclesiastical architecture.

With its austere, domed, Greek cross plan, the struc-
ture ressembled a monument to a secular or philosophic
concept much more than it did a building designed for
the celebration of Catholic rites.

The first important transformation effected
was the removal of Coustou's tympanum or pediment sculp-
tures and their replacement by a relief of Moitte's[67]
Below the sculptures, the inscription "Aux grands
hommes, la patrie reconnaissante," boldly stated the
purpose of the building. The relief depicted a figure
symbolizing France crowning Virtue and Genius with
wreaths, while the spirit of Liberty was seen crushing
Despotism,and the spirit of Philosophy, armed with
the torch of Truth, was shown combating the chimera
of Error and Prejudice (Plate XXIX).[68]

Inside the church, the few existing religious
images were systematically replaced by painted and
sculpted philosophic allegories. Statues of Justice,
la Patrie and Nature were to have filled the area
under the half-domes, whereas under the central dome
an altar dedicated to la Patrie was to have been erected.

The right porch was accorded a relief by

Chaudet[70] entitled _Patriotic Devotion_ which depicted
a young man dying for his country. The left porch
was to have contained a relief by Le Sueur, _Public
Instruction_ which the nation presented to a grateful
people.[71] For the nave, Chaudet was to have done a
group sculpture representing _Philosophy Instructing a
Young Man and Showing Him the Road to Glory and Virtue_.[72]
In the old decorative scheme, Boret had designed con-
certs of angels for the pendentives of the dome. The
new program called for the _Apotheoses of Philosophy_,
Virtue, _Science and Genius_. The north and south tran-
septs of the church were to have been dedicated to
National Science, Agriculture, Commerce and the Fine
Arts, while the crypt under the altar was to house the
remains of the "grands hommes."[73]

The lantern of the building was to have been
crowned by an heroic figure of Fame, twenty-seven feet
high, while the colonnade of the exterior was to have
been surrounded by representations of civic virtue.[74]

Though descriptions of the proposed redecoration
are incomplete and there is little surviving in such
evidence. What exists gives some indication of the

stylistic and iconographic nature of this major revolu-
tionary enterprise of which so little was realized.

The Panthéon project was in every sense the
culmination of the philosophic spirit in art. If com-
pleted it would have constituted a veritable visual
encyclopedia of the Revolution, its dogmas, saints and
liturgy. As the decades preceeding the Revolution had
been dominated by a philosophic quest for a common
morality and as that morality was in large part to be
determined by two concerns, namely, with patriotism
and with posterity, the Panthéon project can justifi-
ably be described as a grandiose effort to materialize
this quest. The festivals were, after all, epnemeral.
At best they could only be remembered through verbal
descriptions or through engravings authorized by the
government. But the Panthéon was to have been a living,
continuing monument. In a sense, it would have symbolized
the very posterity of which the philosophes had written.

The distinguished French sociologist, Emile
Durkheim, attempting to define and categorize the nature
of religious phenomena, stated that a belief in a super-
natural being was not absolutely necessary for a genuine

religious movement. Moreover, he maintained that it was rather by the form than by the content that we recognized religious phenomena.[75] As indications of some of the formal aspects of religion, he cited the following: 1) desire for obligatory belief on the part of the whole group, 2) desire for outward manifestations of the cult through material symbols and ceremonials. The latter he maintained usually involved a persecution of the previous form of religious expression:

> Almost immediately, the religious beliefs concretize themselves in material objects, in symbols, which are at the same time religious talismans....
> Very often, the believers, especially the newly converted, are possessed by a destructive rage which attacks the symbols of other cults....75

For Durkheim, as for other historians, the French Revolution produced a concern with country, with great heroic figures and, finally, with the movement itself which was "...indistinguishable from religious beliefs. The Fatherland, the French Revolution are for us sacred things."[76]

CHAPTER V

Thou shalt cultivate the Fine Arts;
they are the ornaments of the state.[1]

The first years of the revolutionary government
were marked by an extraordinary official interest in
and preoccupation with utilitarian aspects of art and
even saw the development of a program of artistic encour-
agement.[2] In the months following the <u>salon</u> of 1789,
there were numerous suggestions for further official
encouragement.[3] Plans for the transformation of public
squares into living memorials to the revolution and its
prophets flowed from the pens of writers and from the
Commission of Monuments.[4] The projects of Quatremère de
Quincy, discussed in the previous chapter, were in keep-
ing with these ideas and even called for the creation of
lists of deserving great men whose names were to be sub-
mitted by delegates from the various national départments.
Quatremère argued further that the lists of great men
would provide a constant source of artistic inspiration
for painters and sculptors working in the dedicated

service of their country.[5] Yet, what followed in the
next few years was not altogether encouraging to the
partisans of a didatic, moralizing art. We have only
to turn to the revolutionary salons to gauge the effec-
tiveness of governmental influence, and when we do the
evidence indicates that this influence was surprisingly
weak.

The salon of 1791 which opened in September, 1791
may be regarded as the first officially revolutionary
salon. It was the first exhibition which took place
without the Academy's stamp of approval and its exhibitors
were not even subject to the Academy's approval. The
official character of the salon was reflected in the asser-
tion that it was authorized "by order of the National
Assembly."[6] As the government had decreed it an open
salon, by virtue of David's agitation and that of the
Commune of the Arts, the number of works exhibited rose
from slightly more than two hundred in 1789 to over six
hundred.[7]

Of these, by far the largest category of works
was portraiture with nearly two hundred paintings exhib-
ited. The tremendous impetus given to this genre by

the convening of the Estates General and subsequent estab-
lishment of the National Assembly was in large part respon-
sible for the increase in number of portraits produced
since most of the works depicted deputies, the leaders
of the various political clubs, philosophes or popular
military leaders.

Landscapes, seascapes and other views counted
among those works in the second largest category and,
in fact, remained consistently popular throughout the
revolutionary era. The number of religious paintings
was decidedly small, never exceeding twenty or twenty-
five, while classical themes and paintings combining
classical subjects with subjects deemed proper for
the encouragement of civic virtues increased significantly,
as did the number of contemporary political or moralizing
paintings. The subject matter of engravings and sculp-
tures exhibited followed the same pattern of destruc-
tion.

Despite the various plans for governmental
encouragement of the fine arts, little real activity
resulted between 1789 and 1792. While deputies con-
tinued to demand that artists put themselves in the

service of the Revolution, the only actual step taken
in the direction of artistic encouragement was the
establishment, subsequent to the salon of 1791, of a
jury consisting of twenty members of the Academy and
twenty outsiders, which was empowered to award 100,000
livres to artists exhibiting in that salon.[8] In speak-
ing of the salon, the spokesman for the Assembly, Pierre
Veigniaud, stated clearly that the content of the salon
was not sufficiently identified with the Revolution
and its aims and that those artists favored by the
government would have to produce more appropriate works
if the National Assembly were:

> ...to forcefully encourage the arts, which through
> their thoughtful and proper exercise will contribute
> to the happiness of mankind....[9]

The warning was, at least partially, a response
to the somewhat disappointing content of the salon.

Of the works exhibited, the most noteworthy was
David's detailed, sepia drawing for a proposed canvas
of The Tennis Court Oath which had been commissioned by
the Jacobin Club in 1790. The monumental drawing domina-
ted the salon and received the greatest critical atten-
tion (Plate XXX).

In the Explication et critique impartiale de
toutes les peintures, sculptures, gravures et dessins
exposés au Louvre, d'après le décret de l'Assemblée
Nationale au mois de Septembre 1791, l'An II de la
liberté, "le citoyen patriote," M. D., paid lip service
to the artist's function in a free society and then
went on to characterize David's drawing as follows:

> Nothing more ingenious, grand, sublime or poetic
> than the composition of this drawing.... One
> could not have varied the figures more, or the
> expressions of the figures. They exude love
> of country of virtue and of liberty. One recog-
> nizes all of the Catos ready to die for the
> Fatherland. M. David...has the force of patri-
> otism in his heart and has communicated it in
> his drawing....[11]

The Jacobin Club, of which David was a member
for over a year, had agreed to underwrite the costs
of the projected painting and subsequent to the exhi-
bition of the drawing in the salon, the Jacobin dele-
gate, Barère, suggested that the work be subsidized
by the government and placed in the meeting hall of
the National Assembly.

David had requested likenesses of the various
deputies represented, and many of them sat for him.[12]
As a result, he produced sketches of many (Plate XXXI)

in preparation for his work on a canvas which would
have been of monumental proportions (35 by 26 feet).
Though his political activity forced him to abandon
the painting, he did manage to produce the finished
drawing which was not, however, intended to reproduce
exact likenesses. [13]

The work, which was eulogized by the revolu-
tionary poet, André Chénier,[14] Dominated the small
b t significant number of works dealing directly with
contemporary history. In addition, and almost as a reaf-
firmation of their prophetic message, David exhibited
his celebrated paintings of the Oath of the Horatii,
the Death of Socrates and Brutus and the Lictors. The
salon critic whose remarks are quoted above, stated of
the latter work that he would dispense with the usual dis-
cussion because "... everyone knows it is the master-
piece of M. David and one of the masterpieces of
painting." While generally lauding the simplicity and
order of the composition and its "dessin correct," the
critic especially praised the painting for possessing
"un silence triste et lugubre." [15]

By 1793, the number of paintings and drawings

exhibited in the salons had climbed still higher and
there was a proportional increase in the number of
classical scenes and scenes illustrateing contemporary
history or political allegories. The livret of the
salon underlined the official concern with the poten-
tial usefulness of the arts by stating: "We do not
subscribe to the slogan 'in arma silent artes'...."
Reflecting the pressures of wartime conditions, the
livret called some of the exhibitors "the most enthu-
siastic partisans of the government." Among the history
paintings, Perrin's Spartan Assembly was especially
admired and there was praise for the numerous portraits
and portrait busts of the recently martyred Le Peletier
de St.-Fargeau and Matat. Proportionately more descrip-
tion was accorded those paintings which commemorated
recent history, including Demachy's Festival of the
Federation, July 14, 1790 (a representation of the first
civic festival), Thévenin's Fall of the Bastille, Jacques
Bertaux's The Siege of the Tuileries by the Brave Sans-
Culottes (Plate XXXII). These are typical of the contem-
porary history paintings which were augmented by contempor-
ary such as Petit-Coupray's The Departure for the Front

which was apparently a special, sentimental favorite
with reviewers and critics alike. "Two young citizens,
with knapsacks on their shoulders, swear an oath to
defend their country...." Clearly, the painting was
an attempt to translate the classic grandeur of David's
Horatii into an homely, contemporary idiom.

The popular element involved in these contem-
porary history paintings is evident and found constant
expression in the copious graphic work produced by and
for the Revolution. The revolutionary leaders had
maintained that engravings constituted effective vehi-
cles of propaganda and officially encouraged their
production. David's Tennis Court Oath, for example,
was engraved and distributed at government expense, as were
numerous other works.[19]

In the salons from 1789-1799 however, engravings
constituted a relatively small portion of the works exhi-
bited. The salon of 1793 which contained approximately
eighty engravings featured an engraving by Helman
after David's drawing for the Tennis Court Oath and a
representation of the Festival of the Federation in
the Champ de Mars (1790) by Berthault after J. B. Prieur,

as well as a suite of engravings by Lépine and Niquet

representing all the "principle events of the French

Revolution."[20]

The graphic art of the late eighteenth century

is linked to a literary tradition, on the one hand

and to political events, on the other. The great

masters of graphic art in France during the 1780's

and 1790's, **Lavreince,** Moreau le jeune, Debucourt,[21]

produced numerous illustrations for the popular

sentimentalizing and moralizing romances of the day,

as well as illustrations for the philosophic works of

various authors like Voltaire, Rousseau and Raynal.

The famous Monuments du costume (Plate XXXIII) created

by Moreau were really also visual manuals of polite-

ness and elegance directed at a bourgeois audience,

as were the Promenades of Debucourt. (Plate XXXIV)

By far the most interesting graphic work produced--

and the most irregular in quality--was that which

reflected the prose styles of the revolutionary

journals as well as the changing psychological climate

of the contemporary Paris. Though the majority of these

works were never exhibited in the salons, they enjoyed

a wider popular circulation than most paintings and
their very popular nature dictated that they main-
tain continuous contact with their large audience.
A work entitled Virtue Surmounts All Obstacles (1789)
displays a bust of Necker alongside a temple of
Immortality and a colossal personification of Reason.
Its design and the symbolic paraphernalia employed
suggest the drawings for the Festival of the Federation
celebrated the following year or even those drawings
and prints which commemorate the early state funerals
of the "grands hommes" of the Revolution. Reason
in the Act of Explaining the New Divisions of France
while Envy and Hatred Try to Hamper Her, or the Genius
of France Adopting Liberty and Equality (Plate XXXVI),
or Liberty Armed with the Scepter of Reason Conquering
Ignorance and Fanaticism (Plate XXXVII) all date from
about 1790 and relate to contemporary preoccupation
with political reorganization, the plans for a con-
stitution and official antipathy to Christianity.
The compositions all convey the same respect for clas-
sical prototypes, for clear, relief-like space that
is found in the history paintings of the current

salons. More than any other medium graphic art was
capable of responding to the quickening pace of the
revolution. With the execution of the King in 1793,
the threat of Prussian and English invasion and advent
of the terror in the following year, the content of
popular graphic art is drastically altered, and an
often crude, violent and super-realistic art emerges.
A cartoon captioned, Louis the Traitor Read Your
Sentence shows a single powerful arm inscribing a
death message upon a wall, while another work, The
New French Star of the Tri-Colored Cockade Following
the Course of the Zodiac depicts the inevitable progress
of the Revolution and proclaims the coming downfall of
all the monarchs of Europe with gleeful vitality. A
personification of Time extinguishes the candles burn-
ing in the crowns of royal effigies. Finally, a grue-
some caricature of Robespierre's regime which dates
from 1794, the executioner is forced to guillotine
himself as a huge pile of heads indicates that there
are no remaining candidates.[22a]

The Goncourt brothers, who despised the cari-

catures of the revolutionary period, called this graphic
art "l'école du peuple."[23] Certainly, as André Blum
has pointed out in his excellent study of revolution-
ary graphics,[24] the political leaders quickly recognized
that graphics, especially caricatures, were a cheap
means of propagandizing philosophic and political ideas.
Their effectiveness in the government's anti-Christian
campaign has already been discussed, but while some
works served by ridiculing Christianity, others served
by glorifying aspects of the developing civic religion:
sometimes instructing the people in matters of civic
morality, sometimes calling on them to make great
personal sacrifices, often presenting for their consi-
deration and identification the images of the revolution's
martyrs who had made supreme sacrifices. The effective-
ness of graphic art as revolutionary propaganda was
noted as early as 1792 when a critic wrote:

> In all revolutions, caricatures have been employed
> to arouse the people.., they produce prompt and
> terrible effects....[25]

In its early stages of development, the graphic
art maintained a close relationship with the history
and allegorical painting of the day, as we observed in

connection with the Necker print, the ones relating to Reason and the Genius of France. Later, graphic artists were no longer so stylistically or iconographically dependent on contemporary painting of philosophic subjects.

By 1795, the cool intellectualism of official philosophic art had been at least partially displaced by the irrational and passionate currents that had rested dormant, only revealing themselves in the popular graphics and in portaiture.

CHAPTER VI

> Besides, what need have we of
> these eternal representations
> of Greek or Roman subjects.[1]

By January, 1793, David was not only the chief

spokesman for the artist-philosophes, but an important

member of the Jacobin club, a delegate to the Conven-

tion and member of the powerful Committee of Public

Instruction. His participation in the salon of 1791

had, with the exception of his monumental drawing for

the Tennis Court Oath, been a largely retrospective

one. The years 1790 to 1793 had seen him involved

primarily with political activities or with the staging

of the national and civil festivals described in Chapter

IV. His last ancient history painting was the Brutus

exhibited in the salon of 1789 and again in 1791, while

the unfinished Tennis Court Oath belonged to the recent-

ly created category of contemporary history illustra-

tive of civic virtue. Though the religious and philo-

sophic content of the festivals in which David particip-

ated complements the official history painting in that
it renders the ancient contemporary, the festivals seem
to have diverted David's energies from monumental paint-
ing. Moreover, a quick glance at David's output between
the years 1791 and 1799 reveals that he produced no
ancient history painting until 1797, the year in which
he began work on The Sabines. What occupied the artist
during these years, in addition to what has already been
stated, was portraiture. The popularity of this medium
dated from the convocation of the Estates General in
1789 and was further stimulated by the creation of the
National Assembly, but the concern with portraiture
was also a further outgrowth of the late eighteenth
century preoccupation with posterity and with personal
excellence as it was reflected in the writings of the
philosophes and in the sizeable body of popular liter-
ature examined in Chapter II.

Before the Revolution, David had produced a number
of single and group portraits of which his painting of
Lavoisier and His Wife (1788) (Plate XXXIX) is one of
the better examples. Planar space, clearly organized,
careful lighting and a concentration on the tactile

properties of objects is observed. In the portrait of
the delegate to the Convention, Michel Gérard and his
Family (1789) (Plate XL), David offers more of light
and dark and a greater intimacy than the more formal
Lavoisier portrait.

As part of his preparation for the unrealized
canvas depicting the Tennis Court Oath, David had exe-
cuted numerous sketches of the famed participants, of
whom the most notable were Bailly, Barère, Gérard and
the Abbé Grégoire. At the same time, he produced fin-
ished portraits of many delegates, including St. Just,[2]
Boissy d'Anglas[3] and Barère.[4] The portrait of the latter
(Plate XLI), is interesting on a number of counts.[5]
The mise en scène suggests that the celebrated orator
and constitutional is at the tribune, pausing in his add-
ress to confront the spectator. The writings of Diderot
and Caylus and subsequently, the ideas of D'Angiviller,
had called not merely for the representation of great
men, but for a definite choice of action or significant
moment. Though the painting cannot be construed as
heroic in any way, the depiction of the sitter in an
appropriate milieu reflects the same concern with back-

ground and details expressed in David's history paint-

ings. Literary sources and contemporary prints attest

to the fact that portraits of delegates and other

hommes politiques decorated the meeting places of the

Jacobins, Girondins and other political groups, so

there is no need to dwell on the recognized didactic

potential of revolutionary portraiture except in three

special cases where the portraits assumed the aspects

of religious relics since they documented scenes of

martyrdom and virtue.

During the Revolution, virtue had two decided

aspects. On the one hand, there was the notion of a

humble, domestic virtue that proceeded from the popular

morality literature and romances, with no small assis-

tance from the writings of Jean Jacques Rousseau.

This was the sentimental didactic given visual expres-

sion in the works of Greuze, Drolling and other genre

painters. It survived during the Revolution both vis-

ually and in the pronouncements of the revolutionary

leaders, like Robespierre, who commended filial love,

family devotion, simplicity and order, almost as pre-

requisites to that higher civic virtue. Heroic virtue

was still expressed in the epic moments of ancient history, despite the monumental but only partially realized effort made by David in the Tennis Court Oath. For the revolutionaries, the heroic man was the uncompromising moralist who, like Socrates or Brutus, would sacrifice self or sons for the principle of truth.

The Panthéon had been conceived as an official recognition of the virtuous actions of great men in France's past and present. Voltaire and Mirabeau were apotheosized because they had laid the practical and theoretical groundwork for the Revolution, yet in a sense, they still belonged to France's past. The revolutionary cult of great men was, of course, only one phase in the government's search for a new secular faith, but its popularity exceeded that of the other, more transitory cults and was enhanced by public glorification of the "martyrs"--great men who died for preservation of revolutionary principle. The state funerals of Voltaire, Mirabeau and later of Marat and Le Peletier de St.-Fargeau, employed props fashioned after those in official history paintings, but the obsequies, however impressive or moving, were ephemeral and the revolution-

ary organizations wished to immortalize the sacrifices

of these great men through more permanent works of

art.

The increased harshness of the war years and

the collapse of constitutionalism in France produced

the violent climate out of which the martyrs emerged,

and the style of the three major "martyr" portraits

produced by David in 1793 gives expression to those

passions which, in the mid-ninties, darkened "the torch

of reason."

Of the three works, the portrait of Le Peletier

de St.-Fargeau is the earliest. The canvas was begun

in January, 1793, when the deputy was murdered for having

voted for the execution of Louis XVI. On January 27,

1793, the Convention proclaimed that Le Peletier's

death was a national tragedy.

> ...it is not Michel Le pelletier (sic) who has
> been assassinated, it is you...the blow has been
> dealt...against the life of the nation, against
> public liberty, against popular sovereignty.[6]

In addition to the mounting of a state funeral and voting

of pantheonization for Le Peletier, the government auth-

orized a public competition for a marble bust of the

victim to be placed in the hall of the Convention in
accordance with Roman tradition. David assumed the
responsibility for a canvas recalling the corpse of
the deputy as it had been publicly exposed in the Place
Vendôme. He presented his painting, Le Peletier Assass-
inated to the Convention on March 29, 1793, and in ded-
icating the painting to the Convention he once again
voiced his concept of the artist's duties:

> Each of us is accountable to the fatherland
> for the talents which he has received from nature;
> if the form is different, the end ought to be the
> same for all. The true patriot ought to seize
> with avidity every means of enlightening his fel-
> low citizens, and of presenting ceaselessly to
> their eyes the sublime traits of heroism and
> virtue...[7]

The work was warmly received and the Convention decreed
that it should be engraved and distributed throughout
France.

The painting has not survived, but there are two
existing, reliable sources of information about the orig-
inal composition: the partially destroyed proof of the
engraving in the Cabinet des Estampes of the Biblio-
thèque Nationale (Plate XLII) and a drawing, presumably
after the painting, which is in the museum in Dijon
(Plate XLIII). In the drawing and the engraving the

position of the figure is reversed, but one can see that
the basic idea for the composition derived from an early
work, significantly, an ancient history painting, the
Andromache Mourning over the Body of Hector (1783). The
semi-nudity of the figure imparts a religious aura, in
that we inevitably associate the dead, semi-nude figure
with the image of the dead Christ, and, although the
artist borrowed the pose of the figure from the earlier
work [7a] (Plate XLIV), all classical motifs and allusions
have been significantly eliminated and a curious combina-
tion of pathos and horror are engendered by the oversized
bloody sword suspended expressively above the body. The
sword pierces a scrap of paper inscribed "I vote the death
of the tyrant."

It is apparent, both from the speed with which
David executed the painting and from the artist's passion-
ate declarations quoted above that this first martyr
portrait represented a spontaneous and highly personal
reaction which elicited, in turn, a different artistic
response to the problems of portraiture and helped to
develop a new vocabulary of forms--a vocabulary partially
at variance with the rational, abstract tone of earlier

revolutionary ideology.

In David's death portrait of Jean Paul Marat, the simplicity of compositional elements reflected in the portrait of Le Peletier is intensified. The "friend of the people" whom David seems to have idolized, was murdered as he soaked himself in a shoe-shaped tub.[8] According to the reports of a delegation of Jacobin club members headed by David, the day before the assassination he was seen

> ...in his bathtub with a board before him on which he was writing his last thoughts for the people's salvation....[9]

David maintained that he thought it would be interesting to show him in the attitude in which they had discovered him. (Plate XLV)

Again, the artist proposed, as he had in connection with Le Peletier's funeral, that the corpse be publicly displayed with its ugly knife wound, but the warm weather, and the apparent danger of decomposition prevented this. However, the tub and the inkstand were put on public exhibition along with the covered body in the former Church of the Cordeliers.[10]

David had sworn to produce a work equal to his

first portrait, and made sketches shortly after the

discovery of Marat's body. These served as the basis

for the painting which was presented to the Convention

on November 14, 1793. In his presentation speech,

David once more articulated his view of the artist's

duty but he combined these observations with deeply felt

emotion towards the dead Marat:

> It is to you, my colleagues, that I offer
> the homage of my brush; your glances running
> over the livid and blood-stained features of
> Marat will recall to you his ideals, which
> must never cease to be your own...[11]

Staged in semi-darkness, the tub and the writing stand

paralleling the picture plane and the severity of the

horizontals and verticals mitigated only by the curving

diagonals of the shoulder and arm, the painting seems a

curious amalgamation of the basic bodily device from the

Andromache picture with an intimacy of placement and

dramatic chiar'oscuro that is strikingly Caravaggesque.

One has only to compare David's Marat with the

portrait of a lesser contemporary, though dependent

work to appreciate the former's transformation of the

current and anecdotal into the timeless and heroic. A

painting by Roques, an artist from Montauban and one of

the early masters of Ingres, repeats the basic features
of David's composition, in general placement of the
figure, repetition of props, etc., (Plate XLVI). But
the artist's very fussy concern with detail, with the
factual, becomes obsessive in contrast to David's much
more generalized and simple presentation. Where David
softens the ugly features of the radical journalist
(as can be seen if we compare them to a closely dated
anonymous portrait), (Plate XLVII), Roques tends to
exaggerate their grossness in keeping, perhaps, with
his overall reportorial bent.

Although the Convention records indicated that
the order was given for an engraving to be circulated,
only one proof survives, and this work, executed after a
drawing by Copia, preserves only the unforgettable head
of the martyr along with the famed inscriptions,
"A Marat/David" and "L'ami du peuple."[12] (Plate XLVIII)

David's third portrait depicted not a great man,
but a soldier boy, Joseph Bara, the "Decius de treize
ans" who was shot to death in an exchange with counter-
revolutionaries in his native Vendée. In the Convention,

Robespierre called for full state honors for the child
including pantheonization, while David began work on a
canvas depicting his martyrdom. Still another engraving
was called for, and on December 28, 1793, the Convention
expressed the desire that this engraving be circulated
in all the primary schools of France--presumably to
encourage emulation, and to promote "...the example of
love of country and filial tenderness."[13]

The canvas, which was never completed, is a cur-
ious work in which the soft, hermaphroditic form of the
child is complimented by loose brushwork and broken
colors. (Plate XLIX) Employing the antique conceit of
nudity,[14] which in this painting leads to a definite
sense of ambiguity, the child is shown clutching the
tricolor to his breast as he sinks to the ground.
Though the cupid-like figure is close to the spectator,
as in the other martyr portraits, it is not presented
starkly against a neutral background and in almost harsh-
ly concentrated light. Rather, the fugitive landscape
elements tend to further the disintegration of sil-
houette which in the previous pictures was clearly,
even insistently maintained. The work has neither the

powers of the other paintings nor the sense of drama or
significant moment.

Since it is unfinished, it is doubtless unfair to
compare the painting with two closely dated works, the
contested Self Portrait c.1794 (Plate L) and the so-called
Woman of the Market (Plate LI) of the same year or per-
haps a year later. Certain elements in the self-portrait,
the hair, the blurred treatment of the palette, the
scarf and lapels of the coat, contrast markedly with the
former precision of details in portraits of three years
earlier (cf. Barère, Gérard, etc.) not to mention the
technique of the highly finished Tennis Court Oath
drawing. In both the Self Portrait and the Woman of
the Market there is a sense of agitation and a direct-
ness of address absent from other works. Unlike the
martyr portraits in which we untraditionally confront
the sitters, these figures confront us, and in this con-
frontation the element of disquiet alluded to above
results at least partially from the sketchy, unfinished
quality.

Both paintings presumably date from a very diffi-
cult period in David's life. During the Terror, politi-
cal institutions and artistic organizations constituted

earlier in the Revolution were subject to careful and sometimes hostile scrutiny. Initially, artists who admired the Revolution and were opposed to the aristocratic and anti-republican character of the Academy had established the Commune of the Arts which, as was previously pointed out, lasted for about three years until David suggested that it had begun to resemble the body it had displaced and had the Convention surpress it.[15] In November, 1793, the Popular or Republican Society of the Arts was formed and all members had to swear that they had never made anti-revolutionary utterances and that their work was free of frivolous immorality. The avowed purpose of the organization was:

> To love the Republic, hate tyrants,
> sacrifice all for liberty and equality.[16]

The society when it did not investigate the political orthodoxy of artists, promoted the moral usefulness of the arts. A petition presented by the Société to the Convention in January, 1794,[17] called for that body to decree that works of art commemorating heroic and virtuous actions be placed in all public places and

that the populace be constantly lectured on the sub-

ject of civic virtue. As a result of the petition,

the Convention authorized the Committee of Public

Instruction to establish a Concours for the creation

of suitable republican paintings, sculpture and archi-

tecture.

The Société was generally esteemed by the Con-

vention and by the Committee of Public Instruction,

but it was hardly more durable than the Commune of the

Arts. The Revolutionary Club of the Arts, organized

in 1794,[19] had grown out of the jury formed to judge

the works produced for the Concours. No longer were

the members content to be artist-philosophes, rather

they asserted their political nature. "It is not only

necessary to be an artist [one] must also have a truly

republican character."[20]

One of the members, Hassenfratz, voiced a general

feeling that the visual arts would have to demonstrate

their usefulness before receiving official support,[21]

and that they should at all costs propagate republican

ideology. Typcial of the efforts of the Club, and also

reflecting the Committee of Public Safety's interest in

promoting the didactic aspects of the fine arts, was
the commissioning of an engraving (Plate LII) repres-
enting the death of a Jacobin hero, Joseph Chalier,
who organized in 1793 a civil militia in Lyons to
purge reactionary and religious elements from city
government. When the Jacobins were overthrown in
May, 1793, Chalier and his followers were executed
and the engraving by Caresme shows him taking leave
of his followers in prison. Recalling David's
Socrates, in its drama and austerity, the inscription
on the print demands: "Why do you cry... Death is
nothing for one whose intentions are correct and whose
conscience will always be pure.[22]

By 1794, the government through official chan-
nels like the Committee of Public Instruction, the Jury
judging the Concours, and the popular artists' societies
and clubs, had set into motion a program of promoting
morality through encouragement and even control of the
arts. Nor were the visual arts singled out in this
enormous effort to regenerate a nation, the Committee
of Public Instruction appealed to poets, dramatists and
musicians to produce works worthy of the Revolution.

Although political, economic and military unrest

increased during the Spring of 1794, the Committee of

Public Safety issued orders for the execution of the

national monuments chosen from the Concours and even

directed the allotment of precious manpower and mater-

ials to speed their completion, as well as projecting

a plan for still another Concours.[23]

This vast artistic activity was abruptly cur-

tailed by the political events of 9 Thermidor (July

29, 1794), in which Robespierre and the Jacobins were

toppled from power and David was imprisoned for over

five months. Although the artist was cleared of the

charge of terrorism, he lost his political power and

the high degree of artistic control it had engendered.

It also brought about the temporary retirement of the

artist from official art circles. David was not among

the judges selected to confer prizes in the Concours

that had been decreed earlier by the Committee of Public

Safety. The administration of the Concours had rever-

ted to the Committee of Public Instruction which selec-

ted a jury whose decisions were not made public until

September, 1795.[24]

Though prizes in the amount of 442,800 <u>livres</u> were
awarded to the winners, no significant works of art
emerged from the Concours. A sketch by Gérard for a
painting representing the <u>Triumph</u> <u>of</u> <u>the</u> <u>People</u> <u>on</u> <u>August</u>
<u>10th</u> won first prize and second prize was won by David's
old rival, Vincent, who submitted a sketch commemora-
ting the heroic actions of a young woman from the
Vendée.[25] Twenty-three other large moneyed prizes were
awarded and the artists were encouraged to complete their
paintings as quickly as possible and to render them in
a scale suitable for public display. Of all of the
works dealing either with revolutionary themes or sub-
jects suitable for the inculcation of virtue few were
ever completed.

Prud'hon finished a painting of <u>Wisdom</u> <u>and</u> <u>Truth</u>
<u>Descending</u> <u>on</u> <u>the</u> <u>Globe</u>, but most of the other artists
either abandoned their original subjects or altered
them significantly.[26] In place of Public Instruction,
Fragonard the younger, produced a painting of <u>Psyche</u>,
Garnier's <u>The</u> <u>French</u> <u>Republic</u> <u>Renders</u> <u>Homage</u> <u>to</u> <u>the</u> <u>Sup-</u>
<u>reme</u> <u>Being</u> was replaced by one depicting Priam's family,
Taillason's <u>Leander</u> <u>and</u> <u>Hero</u> took the place of <u>Liberty</u>

Leading the People to Justice and Virtue while La
Grenée the younger exchanged a scene marking the events
of the 10th of August for a representation of Ulysses.

Of course these works represented only a few
illustrations of the wholesale defections from the ar-
tistic committment to the Revolution and to the ideals
of philosophic art. There are certainly a number of
possible explanations for these defections. Many art-
ists must have felt that the themes originally chosen
were no longer pertinent to the political situation.
Moreover, without the immense presence of David exert-
ing pressure to execute political and philosophic themes
and without a great popular demand for them, it was pos-
sible for artists to revert easily to nonmoralizing
subjects. However, the main problem seems to have
developed from the inability of the Revolution to devel-
op a more than ephemeral civic faith which would pro-
vide both a real alternative to the dispossessed
Christianity and a constant source of inspiration for
artists. Most aspects of the religions of Reason, the
Supreme Being, and even the Fatherland dictated abstract,
non-narrative visual representations and these caught

the popular imagination. Only the personal statements survived and these probably by virtue of their emotional rather than intellectual appeal.

Despite the withdrawal of many artists from the political arena, the government under the Directory did not abandon the idea of utilizing art in maintaining the progress of the Revolution. There was a continuation of the old antagonism towards Christianity, a retention of the practice of national civic festivals and continued official expression of interest in the fine arts. However, the Directory proved quite unstable and was virtually incapable of pursuing a policy of effective artistic encouragement to match its verbal encouragement. Without the collaboration of a major personality like David, the government program was ineffectual. The number of works exhibited in the _salon_ of 1796 decreased by about two hundred and, in his official statement to the exhibiting artists, the Minister of the Interior, stated the need for new subjects.[27] Still present in his speech was a call for subjects which would preserve great deeds for posterity, but a new and significant note was struck when the official called for the

elimination of ancient history paintings on the grounds
that they were no longer pertinent and that Frenchman
should direct their eyes from the past to the future.[28]
More and more official pronouncements in the late nine-
ties were stamped by this admonition and resulted in
the creation of an official attitude towards the two
types of history paintings which affected the direc-
tion of the arts during the Napoleonic era.

As stated previously, the instability of the
Directory and the wartime hardships caused a falling-
off in government patronage and in artistic involve-
ment with the revolutionary message. In the _salons_ of
1796, 1798 and 1799, there were progressively fewer
paintings exhibited and the number of classical themes
and themes of civic virtue declined correspondingly
from their high point in 1793 to less than forty out
of four hundred in 1799.[29]

In the work of David, the chief representative
of the artist-_philosophe_ the decline in didactic art
in post-Jacobin France is also apparent. Dating from
his imprisonment in 1794, the artist occupied himself
almost exclusively with portraits of which the elegant

M. Seriziat (Plate LIII) is the best known. Thrust
from political life and from active participation in
the government, David seems to have concerned himself
with the reorganization of his studio which, according
to the description transmitted through the reminis-
cences of a pupil,[30] was furnished austerely and class-
ically and contained the painter's Brutus, Horatii and
"a charming sketch of a nude child, dying and pressing
the tricolor to his heart..."[31] Obviously the work
mentioned was the unfinished portrait of the child
martyr, Bara, while the other works were so oversized
that they remained in David's studio till they were
transferred to the Louvre in 1802. From the days of
the studio of the Horatii, David had attracted gifted
pupils, among them Drouais, Girodet, Gérard, Gros and
Wicar. The last three were virtually masters by 1797,
and other young painters[32] had come into the studio
by the time that David commenced work on his first
important history painting in eight years. The subject
chosen for the painting by David was The Sabines (Plate LIV),
not as generally shown in their abduction by the Romans
but in the act of making peace between their husbands

and the Romans. The subject matter is apparently pac-
ifistic, non-political and non-philosophisizing--the
pacifism being hardly unique in the late 1790's.
Pierre-Narcisse Guérin, a pupil of David's one-time
rival, Regnault, presented a painting depicting Marcus
Sextus Returning from Exile in the salon of 1799
(Plate LV). Just as David's history paintings had not
been admired exclusively for their formal beauty but
for their inspiring content, Guérin's work was now
praised primarily for the choice of affecting subject:
the return of the exiled patriot to his home only to
witness the death of his wife as a result of her lengthy
suffering.[33]

Whereas David's choice of subject matter in the
past grew from a passionate commitment to the concept
of philosophic art, in speaking of the Sabines he
eschewed discussions of content and concentrated on
the painting's formal elements. He even expressed dis-
dain for his earlier history paintings, called them
"theatrical" and condemned their muddy colors. Speak-
ing of his new-found preference for Greek art, he first
apologizes for having known only Roman work before and

goes on to maintain:

> I have tried to create something completely
> natural...I want to lead art back to the principles
> practised by the Greeks. In creating the Horatii
> and Brutus, I was still under the Roman influence.
> But, gentlemen, without the Greeks, the Romans would
> have been only Barbarians in art.34

No reference is made to the significance of the theme,

to his role in creating the work and presenting it to

the French public.

At the time David began work on the Canvas, in

1797, the master and his pupils were studying medals,

Etruscan reliefs and vases gleaned from the illustrations

to the famous collections, such as William Hamilton's;[34a]

hence David's famous statement "this painting will be more

Greek." The work was widely criticized, notably by dissi-

dent students in David's atelier,[35] but the brittle,

local colors and sharp outlines served as preparation for

his later representation of Leonidas at Thermopylae (1814)

(Plate LVI).

The arrival of newly acquired art treasures in

France in 1797 and 1798,[36] the French publication of

Lessing's Laocoon (1796) and Kant's Critique of Judgment

(1796) all served to occasion another wave of speculation

on the nature of art, the related question of its moral

function and ultimate destination and the possible causes
for antique superiority in the arts. In his _Essai philo-
sophique sur la dignité des arts_ (1798), Pierre Chaussard
still argued that the arts were the state's most powerful
weapon in its campaign of spreading the enlightenment and
advocated government control of the arts through selective
patronage. Yet in his reviews of the _salons_ of 1798 and
1799,[37] Chaussard reveals an ambiguity towards some paint-
ings which seems to contradict his expressed preference
for philosophic art. Though his reviews stress that
history painting should instruct the body politic and
portraits should likewise honor the Fatherland and preserve
their memory: "The arts should be a moral language...."[38]
Yet he does not refrain from admiring paintings on purely
formal grounds, and he even expresses relief at being able
to appreciate a painting in terms of its visual delights
rather than its message.[39]

 Gone from the writings of critics like LeClerc
Dupuy is the notion that morality, or beauty, resides
exclusively in ancient art. Writing in 1798,[40] he argues,
"Besides, what need have we of these eternal representa-
tions of Greek or Roman subjects...." Like the Minister

of the Interior, Benézech, who advocated the abandoning
of ancient history themes in favor of contemporary sub-
jects, Dupuy argued for the vitality of current events.

After 1800, there was a definite tendency
expressed in the criticism of works of art to dispense
with the old philosophic criterion of moral value.[41]
The beau idéal no longer implied a bon idéal, and aesthe-
tic utility replaced moral utility as the primary criter-
ion for judgment. During the Renaissance and in the
seventeenth century numerous paintings had been produced
for small, informed audiences. These works were frequently
without any explicit moral or didactic value and were
esteemed for their pure visual beauty. The notion of
creating a museum to assist in raising the level of his-
tory painting in France had been expressed as early as
1747, and even the revolutionaries had conceded the purely
aesthetic value of works of art produced in the service
of the old regime when they created the first public
museum in the Louvre.[42] From their original positions
of promoting art in the service of a socio-political
cause, the revolutionary and post revolutionary govern-
ments found themselves promoting art for the sake of

national prestige. Certainly eighteenth century writers
had been concerned with the nation's artistic reputation
and this is surely why virtually every writer began his
observations with a lament over the decline of the grand
manner and then proceeded to present a plan for restoring
it. In order to effect improvement, Caylus, Batteux,
Diderot and others among the philosophes had argued the
need for severity of form and content and had linked the
notion of artistic perfectibility with the contemporary
doctrines of human perfectibility. Thus, the failure of
philosophic neoclassicism to communicate effectively
beyond 1791 or 1792 posed problems that could only be
dealt with on a personal basis in the artist's studio.
It was David's style that had emerged from the various
interpretations of classical themes and motifs, and it
was this same style that prospered only through the first
years of the Revolution. The martyr portraits, though
strikingly effective works, did not produce any signi-
ficant artistic response in other artists and seem, how-
ever strong their naturalistic appeal, to maintain the
classic stereotypes of heroic death.

The compromise inherent in the martyr portraits
articulated the conflict in David's style. He was only

able to reconcile the classic and highly naturalistic ele-
ments he employed because he was still dealing with a per-
sonification of excellence or virtue, only superficially
different from Brutus or Socrates. His martyr portraits
in their idealizations of the subjects still conform to
the classic requisite of universal rather than specific
representation.

A discussion of the official painting in the revo-
lutionary period would be incomplete without this signifi-
cant postscript.

In September, 1804, a decree signed by the Emperor
stated that it was the government's intention to honor
those great works, artistic, scientific and literary, which
had contributed to the glory of France.[42] Desiring to main-
tain the superiority of France in these endeavors, the
decree established awards to be distributed every ten years
and these were entitled Decannal Prizes. It is interesting
to note that when the awards were made in 1810, two cate-
gories of paintings were designated. The first was called
tableaux historiques and among those works and artists hon-
ored in these categories were David for The Sabines, Gérard
for The Three Ages, Girodet for Atala (Plate LVII), Guérin
for his Marcus Sextus (Plate LV) and Phedra and Hippolytus,

Prud'hon for Justice and Divine Vengeance (Plate LVIII)

and Hennequin for The Remorse of Orestes. The second

category was called Tableaux représentant les sujets

honorables pour le caractère national and we are not

surprised to discover that all the paintings relate to

Napoleon: David, Coronation of Napoléon (Plate LXIX),

Girodet, The Emperor Receiving the Keys to Vienna,

Gros, The Pest Hole of Jaffa (Plate IX), Napoléon at

Eylau and the Battle of Moukir, Guérin, Revolt of

Cairo (LXI) and works by Thévenin, Vernet and Debret.[43]

More important than the specific themes is the

fact that the old notion of socio-political utility

has been assumed by the modern history paintings and

that the works in the first category are neither

uniform in their chronology nor in their philosophic

content. Gone is the assumption of the innate moral

superiority of ancient art. Instead the revolu-

tionary preoccupation with France's great men and

its attempt to infuse morality into contemporary

history has been resolved in the person of

the self-proclaimed Emperor.

The Revolution had liberated artists from the control of the Academy in order to create a climate more favorable to the development of a new art in the service of its noble experiment: the moral transformation of society. This transformation, only imperfectly effected through the ephemeral secular faiths, produced a limited identification of artists with the abstract concepts of Reason, the Supreme Being and the Fatherland inherent in the faiths.

The only concept which survived was the one which embodied vitality in the notion of posterity transmitted through the cult of great men of whom Napoleon was to become the most distinguished.

By 1810, _art_ _officiel_ was _art_ _contemporain_ and the visions of classic grandeur no longer dominated criticism but were merely part of an aesthetic concern with the past which included primitive America and medieval Europe as well. Except for a brief renaissance during the upsurge of Republicanism in 1848,[44] philosophic art as _art_ _officiel_ was as dead as the society which produced it.

David himself provided a very accurate summary of what had happened between the collapse of the Revolution, the decline of philosophic art and the rise of the new history painting. Speaking after the Salon of 1808 he predicted:

> In ten years the study of the antique will
> be forsaken. I hear the antique praised...
> and when I look round to see if applica-
> tions of it are made, I find nothing. So
> all those gods, those heroes, will be replaced
> by knights, troubadours...The direction I
> have imprinted on the fine arts is too austere
> to please long in France.[45]

FOOTNOTES

Chapter I.

1. F. M. Grimm, Correspondance littéraire, philoso-
 phique et critique, ed. M. Tourneux (Paris, 1877-
 1882), 16 vols., p. 389.

2. Carl Becker, The Heavenly City of the Eighteenth
 Century Philosophers (New Haven, 1932), p. 13.

3. Ibid., p. 20.

4. Ibid., p. 31.

5. D'Alembert, Mélanges de littérature, d'histoire
 et de philosophie (Amsterdam, 1759), Vol. IV, pp. 3-6.

6. Ernst Cassirer, The Philosophy of the Enlightenment
 (New York, 1954), p. 14.

7. Denis Diderot, "De la suffissance de la religion
 naturelle," Oeuvres complètes (Paris, 1876), 20 vols.,
 VII, p. 356.

8. Ibid., p. 357.

9. Diderot translated Shaftsbury's Essay on Merit and
 Virtue in 1745, while Tindal's Religion within the
 Bounds of Mere Reason was well known in France after
 1730.

10. Albert Mathiez, La Révolution et l'Eglise (Paris, 1910),
 p. 9.

11. Jean-Jacques Rousseau, Social Contract, ed. Sir Ernest
 Barker (London, 1946), Book V., Chapter VIII., p. 437-8

12. Mathiez, p. 137.

162.

13. See F. Garffe, <u>Etude sur le drame en France au XVIIIe siècle</u> (Paris, 1916).

14. Mathiez, <u>loc</u>. <u>cit</u>.; see also F. A. Aulard, <u>Christianity and the French Revolution</u> (Boston, 1927), p. 38.

15. Mathiez, p. 24.

16. <u>Idem</u>.

17. Harold T. Parker, <u>The Cult of Antiquity</u> (Chicago, 1937) documents the widespread influence of classical education and, especially, of Plutarch and Livy.

18. William Gibbon, <u>Decline and Fall of the Roman Empire</u> (London, 1776-1788), Vol. III, pp. 239-40.

19. Becker, p. 16.

20. <u>Ibid</u>., p. 13.

21. See Edgar Quinet, <u>Oeuvres complètes</u> (Paris, 1857), 10 vols., especially <u>La Génie de Réligion en France</u> and <u>Le Mysticisme democratique</u>.

22. Pierre-Simon Ballanche, <u>Essai de Palengenésie</u> social (Paris, 1827-29), 2 vols.

23. Jules Michelet, <u>Histoire de la Révolution française</u> (Paris, 1847-53), 7 vols.

24. Joseph C. Sloane, "Baudelaire, Chenevard and Philosophic Art." <u>Journal of Aesthetics and Art Criticism</u>, XIII (1955), pp. 285-299; the same author's Paul Marc <u>Joseph Chenevard</u> (Chapel Hill, 1962) treats more extensively of this subject.

25. Daniel Mornet, <u>Les Origines intellectuelles de la Révolution française</u> 1715-87 (Paris, 1938), p. 264.

26. Parker, p. 179.

27. Camille Desmoulins was the publisher of the influ-
ential journal, Révolutions de France et Brabant.

Chapter II.

1. Andre Fontaine, Les Doctrines d'Art en France de
Poussin à Diderot (Paris, 1909), p. 295.

2. This figure is based on an examination of the
livrets of salons from 1740 through the revolution-
ary period.

3. From the Correspondance de Nicolas Poussin quoted in
Elizabeth G. Holt, A Documentary History of Art
(New York, 1958), 2 vols., II, p. 142.

4. See Helmut Hatzfeld, Litterature through Art (New
York, 1952), pp. 63-84.

5. Diderot, Oeuvres complètes, X, p. 499.

6. The nine salons appear without illustrations in vols.
X, XI, and XII of the Oeuvres complètes. Although
the edition of the Salons ed. by J. Seznec and J.
Adhemar (Oxford, 1957 --) is, as yet, incomplete,
the volumes are illustrated.

7. Plato, The Republic, III, 401-2; Aristotle, Politics,
VIII, 5, 21.

8. J. J. Winckelmann, Gedanken über die Nachahmung der
griechischen werke in der Malerei und Bildhauerkunst
(Dresden, 1755), p. 79.

9. Ibid, paragraph 9.

10. Comte de Caylus, Nouveaux sujets de peinture et
de sculpture (Paris, 1814), p. 14.

11. Ibid., p. 55.

12. Comte de Caylus, Parallèle de la peinture et de la sculpture (Paris, 1814), p. 7.

13. Ibid., p. 17.

14. Ibid., p. 8.

15. Idem.

16. Samuel Rocheblave, Essai sur le comte de Caylus (Paris, 1889), p. 180.

17. La Font de St.-Yenne, Réflexions sur quelques causes de l'état present de la peinture en France (The Hague, 1747), pp. 2-4, 8.

18. La Font de St.-Yenne, Sentiments sur quelques ouvrages de Peinture, sculpture et gravure (Paris, 1754), p. 51

19. Charles Batteux, Les Beaux-Arts reduits à un même principe (Paris, 1747), p. 248 ff.

20. Diderot, Oeuvres complètes, X, p. 128.

21. Idem.

21a. Jean Seznec, Essai sur Diderot et l'Antiquite, (Oxford, 1957), pp. 4, 8, 12, 15.

22. Diderot, II, p. 345

23. Ibid., p. 139.

24. Ibid., 502-03.

25. Idem.

26. Ibid., X, pp. 5-42.

27. Ibid., p. 178.

28. Cf. Batteux, p. 248; Caylus, Parallèle de la Peinture, p. 7; Winckelmann, paragraph 79.

29. Diderot, Oeuvres complètes, XI, p. 249, 252; Seznec, p. 99.

30. Daniel Mornet, Le Sentiment de la Nature de Rousseau à Bernardin de Saint-Pierre (Paris, 1907); Albert Schinz, "Le mouvement Rousseauiste du dernier quart de siècle: Essai de Bibliographie critique," Modern Philology (Nov., 1922), pp. 67-83.

31. F. Courboin, L'Estampe francais au XVIIIe siècle, (Brussels, 1914), p. 7.

32. See chapters V and VI for the discussion of the persistence of genre painting during the Revolution.

33. Salon de 1767 in Oeuvres complètes, Vol. XI, p. 31.

34. Charles Claude de la Billarderie, Comte d'Angiviller, Correspondance de M. d'Angiviller avec Pierre, ed. M. Furcy-Raynaud Nouvelles archives de l'art francais, (Paris, 1906), Vol. XXI, pp. 42-43.

35. Jean Locquin, La Peinture d'histoire en France de 1747 à 1785 (Paris, 1912), p. 51.

36. Ibid., pp. 16-17.

37. Ibid. , pp. 25-27.

38. See the Correspondance de M. de Marigny avec Coypel, Lépicié et Cochin, ed. M. Furcy-Raynaud Nouvelles archives de l'art francais, Vol. XX, p. 324.

39. Ibid., p. 325

40. Letter dated June 27, 1775 in Correspondance de M. d'Angiviller avec Pierre, Vol. XXI, p. 43.

41. Idem.

42. Locquin, p. 52.

43. Correspondance de M. d'Angiviller..., Vol. XXI, p. 43.

Chapter III.

1. Miette de Villars, Mémoires de David (Paris, 1850), p. 65.

2. Louis Hautecoeur, Rome et la renaissance de l'antiquité (Paris, 1912), p. 158.

3. A. F. Lemaire, Lettre bougrement patriotique du véritable Père Duchêne, no. 212 (Paris, n.d.), p. 4.

4. Procès-verbaux de l'Académie royale de peinture et de sculpture, 1648-1793, ed. A. de C. de Montaiglon (Paris, 1875-1909), 11 Vols., IX, 76-77.

5. Diderot, "Salon de 1781," Oeuvres Complètes, XII, pp. 63-64.

6. F.M. Grimm, Correspondance secrète, politique et littéraire (London, 1787-90), p. 84.

7. Procès-verbaux de l'Académie royale..., IX, 164.

8. Letter of David's pupil, Germain Drouais, August 14, 1785; Letter of David to Marquis de Bièvre, August 28, 1785 quoted in Miette de Villars, pp. 93-94; see also E. J. Delécluze, Louis David, son école et son temps; souvenirs (Paris, 1855), p. 118.

9. Miette de Villars, pp. 88-90.

10. Barker, p. 34.

11. Parker, p. 42; see also Edgar Wind, "A Lost Article on David by Reynolds," Journal of the Warburg and Courtauld Institutes (1943), VI, pp. 223-224, who states that David's work was based on Charles Rollin's Histoire Romaine. For refutation of this opinion, compare Titus Livius, Ab urbe condita, Bk. I, Chapter XXVI.

12. W. J. Friedlaender, From David to Delacroix (Cambridge, 1952), p. 16.

13. P. J. Chaussard, Notice sur la vie et les ouvrages de M. J.-L. David (Paris, 1824), p. 31.

14. Cochin quoted in Richard Cantinelle, Jacques Louis David (Paris, 1939), p. 23.

15. See E. Roy, Vien et son temps (Paris, 1886).

16. For discussions of David's Roman years and the various influences on him, see: Chaussard, pp. 14-15, 148; Miette de Villars, pp. 6, 37, 65-67; Delecluze, pp. 111, 113 .

17. Miette de Villars, loc. cit.

18. J. J. Sue, "Rapport sur les tableaux de David," L'Esprit des journeaux, VIII (August, 1793), p. 275, cites the artist as having devoted his entire first year in Rome to the study of ancient sculpture, particularly the reliefs of the Arch of Trajan.

19. Vérités agréables ou le Salon vu en Beau (Paris, 1789), p. 16.

20. Ibid., p. 17

21. See discussion in Chapter II.

22. Wind, p. 224.

23. Leo Gershoy, The French Revolution and Napoleon (New York, 1933), p. 110.

24. Ibid., pp. 111-112.

25. Desmoulins' journal, Révolutions de France et de Brabant, was one of the earlier radical prototypes.

26. Gershoy, pp. 117-119.

27. The group had formerly been the citizen militia of Paris.

28. August 25, 1789.

29. Jules David, Le peintre Louis David (Paris, 1867), p. 54.

30. E. and J. de Goncourt, Histoire de la société française pendant la Révolution (Paris, 1904, p. 44.

31. L'Observateur, no. 3 (August, 1789), pp. 9-10; no. 4, p. 22.

32. Correspondance de M. d'Angiviller avec Pierre, II, 263.

33. Friedlaender, p. 18.

34. David, pp. 53-54.

35. David, p. 12.

36. Vérités agréables ou le Salon vu en Beau, 1789 (Paris, 1789), p. 22-23.

37. Lionello Venturi, "Doctrines d'Art au début du XIXe siècle," Renaissance, I (New York, 1943), p. 563.

38. Correspondance de M. d'Angiviller avec Pierre, II, 265.

39. Journal de Paris, no. 89 (March 30, 1777), p. 2.

40. Pierre who was Premier peintre au roi and David's main rival in the 1780's had voted against him and also tried to have his name taken from the list of exhibitors for the salon of 1789, see David, pp. 53-54.

41. Letter from David to his pupil, Wicar quoted in Rene Schneider, Quatremère de Quincy et son Intervention dans les arts, 1788-1830 (Paris, 1910), p. 159.

42. Contemporary journals carried the contents of the pamphlet as well as the Academy's rebuttal: L'Observateur, no. 19 (September 22, 1789), pp. 137-139; Procès-verbaux de l'Académie royale de peinture et de sculpture, X, 24-26.

43. L'Observateur, no. 19, p. 139.

44. Count Paroy, Précis historique de l'origine de l'Académie royale de peinture (Paris, 1816), pp. 31-32.

45. Procès-verbaux de l'Académie royale de peinture et de sculpture, X, 39; Démande faite à l'Académie... du 5 decembre 1789 (Paris, n.d.).

46. February 4, 1790.

47. Procès-verbal de l'Assemblée nationale (Constituante) (Paris, 1790), XXIII, 40; Journal des débats et des décrets, no. 327 (Paris, n.d.), pp. 1-2; Adresse des représentants des beaux-arts à l'Assemblée nationale dans la séance du 28 juin 1790 (Paris, 1790).

48. Chronique de Paris, no. 216 (August 4, 1790), p. 861, examined and explained the text for its readers.

49. Procès-verbaux de l'Académie royale de peinture et de sculpture, X, 138-39.

50. Collection génerale des décrets rendus par l'Assemblée nationale (Paris, 1791), XVII, 322-23.

51. Considérations sur les arts du dessin en France... (Paris, 1791), p. 31.

Chapter IV:

1. Aulard, p. 104.

2. Mathiez, pp. 6, 9.

3. Aulard, p. 104.

4. Gershoy, p. 165.

5. Social Contract, p. 437.

6. Ibid. cf., Chapter I, f. 11.

7. Idem.

8. **Math**iez, loc. cit.; Gershoy, p. 167.

9. Mathiez, p. 14.

10. Gershoy, p. 168.

11. Aulard, p. 98.

12. Idem.

13. Gershoy, p. 171.

14. The king and queen wished to spend Easter at St. Cloud where they would have access to non-juring clergy. Instead of remaining there however, they continued on to the eastern frontier and were apprehended at Varennes.

15. The Swiss guards defending the Tuileries were slaughtered and the mobs attacked all "royalist sympathizers" of whom priests were generally considered to be among the strongest.

16. Decree authorized by Fouché, quoted in Mathiez, p. 229.

17. Ibid., pp. 234-35.

18. Idem.

19. Quoted by Mathiez, p. 16.

20. Quatremère de Quincy, pp. 52-55, 163.

21. S. J. Idzerda, "Iconoclasm during the French Revolution," _American Historical Review_ (October, 1954), p. 14.

22. Diderot, Oeuvres complètes, X, p. 502.

23. Idzerda, p. 15.

24. Aulard, pp. 90-93

25. Albert Mathiez, _Les origines des cultes révolutionnaires_ (Paris, 1904), p. 112.

26. Mathiez, p. 106.

27. _Procès-verbaux de la Commission des Monuments_, ed. L. Tuetey (Paris, 1912).

28. _Procès-verbaux de la Commission temporaire des Arts_, ed. L. Tuetey (Paris, 1912).

29. Dowd, p. 90.

30. _Procès-verbal de la Convention nationale imprimé par son ordre_ (Paris, 1792-95), XXIX, 278-80.

31. St. Yenne in the _Réflexions_ had called for "un lieu propre pour placer à demeurer les innombrables chefs d'oeuvres des plus grands maîtres de l'Europe," p. 55.

32. Mathiez, p. 74.

33. Aulard, p. 104.

34. Mathiez, _op. cit._, p. 77.

35. Rousseau, _Oeuvres complètes_, ed. Musset-Pathay (Paris, 1824), II, 175-76.

36. Spire Blondel, _L'Art pendant la Révolution_ (Paris, 1887), p. 162.

37. On revolutionary festivals: Blondel, op. cit.;
 Julien Tiersot, Les fêtes et les chants de la
 révolution (Paris, 1908); Maurice Dommanget, Le
 symbolisme et le proselytisme révolutionnaire
 (Beauvais, 1932); David L. Dowd, Pageant Master
 of the Republic.

38. André Chénier, Avis aux Français in Oeuvres complètes,
 ed. Dimoff (Paris, 1920), III, 228.

39. Aulard, p. 65.

40. Procès-verbal de la Convention nationale..., XII,
 297; Report of David and decree in Procès-verbal de
 la Convention nationale..., XIV, 52.

41. Annales patriotiques, no. 223 (August 12, 1793), pp.
 1025-1026, 1029-1030.

42. Blondel, pp. 168-70.

43. Ibid., p. 171.

44. W. Henley Jarvis, The Gallican Church and the
 Revolution, (London, 1882), p. 247.

45. Albert Mathiez, "Robespierre et le culte de l'Etre
 Suprême," Annales Revolutionnaires, 32 vols. (Paris,
 1910), III, 209-38.

46. Aulard, p. 126.

47. Blondel, p. 173.

48. Accounts of the festival given in: Moniteur, no. 265,
 1077; Le Républicain français, no. 567, pp. 2329-30;
 Journal de France. See also: Détail des cerémonies
 et de l'ordre à observer dans la fête à l'Etre suprême
 (Paris, 1794); Dowd, pp. 121-23.

49. Aulard, p. 131.

50. D. Thiebault, "Mémoire sur les fêtes nationales," Journal de l'instruction publique, VII, no. 37 (nd), pp. 298-99.

51. Blondel, p. 161.

52. Collection générale des décrets rendus..., ed. F. J. Baudouin (Paris, 189-99), 79 vols. XIV, 83.

53. Lettres choisies de Charles Villette (Paris, 1792), p. 190.

54. See Chapter III.

55. Examples in the Collection de Vinck, nos. 4171-80; Collection complète des tableaux historiques de la Révolution française (Paris, 1802), I, 220.

56. Révolutions de France et de Brabant, no. 85 (n.d.), pp. 290-91.

57. Dowd, p. 55.

58. Détail et ordre de la marche de la fête en l'honneur de la liberté donnée par le peuple à l'occasion de l'arivée des soldats de Chateauvieux...15 avril, 1792... (Paris, 1792); Dowd, pp. 58-60.

59. See Chapter V.

60. Ordre de la marche et des cérémonies qui seront observé aux funerailles de Michel le Pelletier (sic) (Paris, 1793); Defenseur de la vérité, no. 4 (January 26, 1793), pp. 61-3; Auditeur National, no. 123 (January 23, 1793), pp. 6-7, no. 126 (January 26, 1793), pp. 5-6.

61. Procès-verbal de la Convention nationale..., V, 403.

62. Blondel, p. 164.

63. Courier Français, no. 198 (July 17, 1793), pp. 3, 6; Journal de la Montagne, no. 48 (July 19, 1793), p. 278.

64. David proposed "pantheonization" for Bara on July 11, 1794 but the plans were cancelled by the government crisis resulting from the fall of Robespierre and the Jacobins, David, pp. 208-16.

65. Schneider, pp. 152, 162.

66. Archives parlementaires de 1787 a 1860; Recueil completes des débats legislatifs..., ed. J. Mandal et al (Paris, 1837-1913), 82 vols., XXiv, p. 536.

67. Joachim Le Breton, Rapport à l'Empereur et Roi sur les Beaux-Arts depuis vingt dernières années (Paris, 1808); Ph. Chennevieres-Pointel, Les Décorations du Panthéon (Paris, 1885); Jean Monval, Le Panthéon (Paris, 1951).

68. Chennevieres-Pointel, p. 12.

69. Ibid., p. 13.

70. Ibid., p. 14.

71. Ibid., p. 16.

72. Ibid., p. 17.

73. Ibid., p. 21.

74. Ibid., pp. 22-23.

75. Emile Durkheim, "De la définition des phenomènes religieux," Année Sociologique (Paris, 1899), II, pp. 12-14, 24.

76. Ibid., p. 13

77. Ibid., p. 20.

Chapter V:

1. Republican version of the Ten Commandments issued in 1793, quoted in Idzerda, p. 14.

2. Establishment by the Legislative Assembly in October, 1791 of a Jury to distribute 100,000 livres for the encouragement of works glorifying the Revolution.

3. Nouvelle Critique impartiale du Salon par une société d'artistes, no. 1 (Paris, 1791).

4. Procès-verbaux de la Commission des Monuments 1790-1794, I, p. 4; A.-G. Kersaint, Discours sur les monuments publics prononcé au conseil du departement de Paris le 15 decembre 1791 (Paris, 1792); Chevalier de Mopinot, Proposition d'un monument à élever dans la capitale de France pour transmettre aux races futures l'époque heureuse révolutionnaire (Paris, 1790).

5. Quincy, pp. 52-55.

6. Livret de salon de 1791.

7. Livrets for the salons of 1789, 1791.

8. Procès-verbaux des assemblées du jury élu par les artistes éxposants au Salon de 1791, ed. M. Furcy-Raynaud (Paris, 1906).

9. Archives parlimentaire de 1787 a 1860, Vol. XXXIV, pp. 281-82.

10. Explication et critique impartiale de toutes les peintures... (Paris, 1791), p. 20.

11. Bertrand Barère, Point du jour, no. 812 (September 29, 1791), pp. 509-10.

12. The following sketches are preserved: Bailly (Louvre), Barère (Versailles), Père Gérard and Abbé Grégoire (Besançon).

13. "L'auteur n'a pas eu l'intention de donner la res-
 semblance aux membres de l'Assemblée," Ouvrages...
 exposés au sallon (sic) de 1791, no. 32.

14. "Le Jeu de Paume à Louis David, peintre," Oeuvres
 Complètes, III, 230-43.

15. Explication et critique impartiale de toutes les
 peintures, sculptures, gravures et dessins exposés
 au Louvre, d'après le décret de l'Assemblée nationale,
 au mois de septembre 1791, l'an IIIe de la liberté
 (Paris, 1791), p. 20.

16. Ibid., p. 22.

17. Ibid., p. 35.

18. Livret du Salon de 1791, no. 103.

19. F. Courboin, L'Estampe française au XVIIIe siècle,
 (Bruxxels, 1914), pp. 281-85.

20. Livret du Salon de 1793, no. 436.

21. Jean Adhémar, La Gravure originale au XVIIIe siècle
 (Paris, 1963), p. 172 cites the attempts to inculcate
 domestic morality through illustrated texts.

22. See Adhemar, pp. 121-3.

22a. For material cited but not reproduced in plates see
 Ernest Henderson , Symbol and Satire in the French
 Revolution (New York, 1912).

23. E. and J. de Goncourt, p. 270.

24. A. Blum, L'Estampe satirique et la caricature en
 France au XVIIIe siècle (Paris, 1910). p. 21.

25. Adhemar, p. 191.

Chapter VI:

1. Leclerc Dupuy, Mémoire de l'An VI (Paris, 1799), p. 50.

2. Musée Carnavalet.

3. Musée Carnavalet.

4. Musée de Versailles.

5. Jules David, Quelques Observations... (Paris, 1883), pp. 14 - 16, has questioned the authorship of the portrait and suggested that it is by Laneuville rather than David. Prosper Dorbec, "Le portrait pendant la Révolution," Revue de l'Art ancien et moderne, XXI (1907), p. 41, concurs in the attribution to David's pupil, although the sale of the portrait in 1898 included a signed letter of Barere's referring to the work as being by the "immortel David."

6. Collection générale des décrets rendus..., XXVIII, 344, 346.

7. Procès-verbal de la Convention nationale..., VIII, 386, 89.

7a. While it has been pointed that the Le Peletier is dependent on the earlier Andromache, it should be noted that this composition is itself indebted to a painting of the same subject by Gavin Hamilton (1769), while the latter certainly derives from Poussin's Death of Germanicus.

8. The curious tub is generally represented in popular graphic depictions of the assasination. See Plate XXXIXa.

9. _Archives parlimentaires de 1787 à 1860, LXXIX_, p. 211.

10. Descriptions in virtually all Paris newspapers in-
cluding _Courier français_, no. 198 (July 17, 1793),
pp. 3, 6; _Journal de la Montagne_, no. 48 (July 19,
1793), p. 278.

11. _Procès-verbal de la Convention nationale_, XXV, 221-
222; _Journal de l'instruction publique_, IV, pp. 153-55.

12. Additional information of the painting in F. Chevre-
ment, _Marat_ (Paris, 1876), pp. 351-53; C. Saunier,
"Le Marat expirant de Louis David et ses copies,"
Gazette des Beaux Arts, ser. 4, X (June, 1913), pp.
24-31.

13. _Procès-verbal de la Convention nationale..._, XXVIII, 148.

14. Since the work is unfinished, it is quite possible
that this nudity represents a preliminary stage, and
that David would have painted in the costume subse-
quently as in the _Tennis Court Oath_.

15. _Procès-verbaux de la Commune générale des arts_, ed.
H. Lapauze (Paris, 1903), pp. 4-5; H. Lapauze, "Une
Académie des Beaux-Arts révolutionnaire," _Revue des
deux mondes_, ser. 5, XVIII (December, 1903), 890.

16. A. Detournelle, _Aux armes et aux arts! Peinture,
sculpture, architecture et gravure. Journal de la
société républicaine des arts séant au Louvre_, (n.d.),
pp. 5-6.

17. _Ibid._, p. 14.

18. _Procès-verbaux du Comité d'instruction publique de la
Convention nationale_, ed. J. Guillaume, (Paris, 1891-
1907), V, pp. 168, 175.

19. _Ibid._, p. 171.

20. _Ibid._, p. 262.

21. Ibid., p. 282.

22. F. A. Aulard, "L'Art et la politique en l'an II," Etudes et leçons sur la Révolution française, Iere sér. (Paris, 1893), vol. I, p. 252.

23. Archives de l'art francais. Recueil de documents inédits, ed. P. de Chennevieres and A. de C. de Montaiglon (Paris, 1851-63), II, 80, dossier 590.

24. Procès-verbaux du Comité d'instruction publique de la Convention nationale, VI, pp. 293, 596, 606.

25. Prix décernés aux esquisses de peinture presentées au concours ouvert par la Convention nationale et soumises au jugement du jury des arts en vertu de la loi du 9 frimaire an III (Paris, n.d.).

26. Rapports sur les travaux d'encouragements faits au ministre de l'interieur le 3 ventôse an V, (Paris, 1797).

27. Avis du ministre de l'intérieur relatif à l'exposition qui s'ouvrira le 1er vendemaire an V (September, 1796), p. 27.

28. Ibid., p. 28.

29. Figures are based on examination of the livrets for the two salons.

30. Delécluze, p. 276.

31. Ibid., p. 278.

32. Ingres, Charles Nodier, Maurice Quai.

33. Many critics and viewers considered the work a comment on the pitiful situation of emigrés who had been forced to leave during the Revolution and returned in destitution during the Directory.

34. Delécluze, p. 475.

34a. David, p. 476 cites an illustration from Montfaucon's
 Antiquité expliquée, XV, 4 as a direct source of in-
 spiration for the composition of The Sabines.

35. Their dissatisfaction with the painting led Quai and
 his Primitifs to break with David in a demand for
 less plastic forms.

36. Gershoy, p. 194 .

37. Pierre Chaussard, "Exposition des ouvrages... ex-
 posés dans le Salon an VI," Décade philosophique,
 vol. XVIII (Paris, 1797).

38. Ibid., p. 417

39. Décade philosophique, vol. XXIII, p. 213.

40. Dupuy, loc. cit.

41. Fontaine, p. 297.

42. See Chapter III for discussion of La Font de St.-
 Yenne and D'Angiviller's plans for the establishment
 of museums.

42a. David, pp. 404-5.

43. Ibid. pp. 464-5.

44. See Chapter I, f. 24 for references to Chenevard's
 attempt to revive a liberal, philosophic art in
 the decorative scheme for the Pantheon.

45. Louis Hautecoeur, Littérature et peinture en France,
 (Paris, 1963), p. 50.

SELECTED BIBLIOGRAPHY

Collections of Contemporary Documents:

Archives de l'art français. Recueil de documents inédits, published by P. de Chennevieres, A. de C. de Montaiglon and others, 8 vols., Paris, 1851-1863.

Archives parlementaires de 1787 à 1860; Recueil complète des débats legislatifs ..., ed. by J. Mandal and others, 82 vols., Paris, 1867-1913.

Collection générale des décrets rendus ... (mai, 1789-nivoise an VIII), ed. by F.J. Baudouin, 79 vols., Paris, 1789-1799.

Journal des débats et des décrets, 42 vols., Versailles and Paris, 1789-1797.

Procès-verbal de l'Assemblée nationale (Constituante) imprimé par son ordre, 75 vols., Paris, 1789-1791.

Procès-verbal de l'Assemblée nationale (legislative) imprimé par son ordre, 16 vols., Paris, 1791-1792.

Procès-verbal de la Convention nationale imprimé par son ordre, 72 vols., Paris, 1792-1795.

Procès-verbaux de l'Académie royale de peinture et de sculpture, 1648-1793, ed. by A. De C. de Montaiglon, 11 vols., Paris, 1875-1909.

Procès-verbaux de la Commune générale des arts, ed. by H. Lapauze, Paris, 1903.

Procès-verbaux du Comité d'instruction publique de la convention nationale, ed. by J. Guillaume, 6 vols., Paris, 1891-1907.

Recueil des actes du Comité de salut publique, ed. by F.A. Aulard, 27 vols., Paris, 1889-1933.

Contemporary Correspondance, Memoirs:

Correspondance de M. d'Angiviller avec Pierre, ed. by M. Furcy-Raynaud, 2 vols., Paris, 1906-1907.

Correspondance des Directeurs de l'Académie de France à Rome avec les Surintendants de batiments, 1666-1804, ed. by A. de C. de Montaiglon and others, 17 vols., Paris, 1887-1908.

Correspondance littéraire, philosophique et critique, F. M. Grimm and others, ed. by M. Tourneux, 16 vols., Paris, 1877-1882.

Revolutionary Journals, Pamphlets, etc.:

Barère, Bertrand. Le point du jour, ou Résultat de ce qui c'est passé la veille a l'Assemblée nationale, 26 vols., June, 1789-October, 1791.

Brissot, J. Le Patriote françois (sic), July, 1789-June, 1793.

Desmoulins, Camille. Révolutions de France et de Brabant, 8 vols., November, 1789-December, 1791.

Feydel, Gabriel. L'Observateur, August, 1789-October, 1790.

Hebert, J.R. Je suis le véritable Père Duchène, foutre, September, 1790-1794.

Lemaire, A.F. Lettres bougrement patriotiques du véritable Père Duchène, 1790-92.

_____. La Trompette du Père Duchène, 1792-1793.

Marat, J.P. L'Ami du Peuple ou le Publiciste parisien, September, 1789-September, 1792.

Mercier, L.S. Annales patriotiques et littéraires de la France, 21 vols., October, 1789-June, 1797.

Prudhomme, L.M., Révolutions de Paris, 17 vols., July, 1789-February, 1794.

Rabaut St.-Etienne, J.P. La Feuille villageoise, 10 vols., September, 1790-August, 1795.

Rousseau, P. Journal encyclopédique, 304 vols., Liège, 175601793.

Thiebault, D. Journal de l'instruction publique, 8 vols., July, 1793-September, 1794.

Billaud-Varenne, J.N. Rapport fait à la Convention nationale au nom du Comités de salut public (sic) ... 1, floréal an II sur la théorie du gouvernement democratique ... et sur la necessité d'inspirer l'amour des vertus civiles par les fêtes publiques et des institutions morales, Paris, 1794.

Boissy d'Anglas, Francois Antoine. Essai sur les fêtes nationales adressé a la Convention nationale ... 12 messidor an II, Paris, 1794.

Chénier, Marie-Joseph. Discours prononcé à la Convention nationale ... 15 brumaire an II ... de l'instruction publique ..., Paris, 1793.

_____. Rapport fait à la Convention nationale au nom des Comités d'instruction publique et des inspecteurs ..., Paris, 1793.

David, Jacques-Louis. Détail des cérémonies et de l'ordre à observer dans la fête a l'Etre-suprême qui doit être célebrée le 20 prairial d'après le décret de la Convention nationale du 18 floreal, Paris, 1794.

_____. Discours prononcé à la Convention nationale sur l'érection d'un monument au Peuple francais ... 17 brumaire, l'an II, Paris, 1793.

_____. Discours prononcé à la Convention nationale ... en lui offrant le tableau représentant Marat assassiné ... 24 brumaire, l'an II ..., Paris, 1793.

_____. Discours prononcé à la Convention nationale, le 29 mars 1793 ... en offrant un tableau de sa composition représentant Michel Lepelletier au lit de mort ..., Paris, 1793.

_____. Instruction pour l'ordre à observer le jour de la fête de la réunion, au 10 aout, l'an II..., Paris, 1793.

_____. Rapport fait à la Convention nationale au nom du Comité d'instruction publique ... sur la nomination des cinquante membres du jury qui doit juger le concours des prix de peinture, sculpture et architecture ... 25 brumaire, l'an II, Paris, 1793.

_____. Rapport fait à la Convention nationale sur la fête héroique pour les honneurs du Panthéon a décerner aux jeunes Bara et Viala ... 23 messidor, l'an II, Paris, 1794.

_____. Rapport fait à la Convention nationale sur la suppression de la Commission du Museum ..., Paris, 1794.

David, Jacques-Louis and others. Adresse des representans des beaux-arts à l'Assemblée nationale (Constituante), dans la séance du 28 juin 1790, Paris, 1790.

De Bry, Jean Antoine Joseph, Rapport à l'Assemblée nationale legislative sur les honneurs a rendre a la mémoire de J.-G. Simonneau, Maire de' Etampes fait au nom du Comité d'instruction publique, et décret du 18 mars 1792 ..., Paris, 1792.

Détail et ordre de la marche de la fête en l'honneur de
la liberté, donnée par le peuple a l'occasion de l'arrivée
des soldats de Chateauvieux, Paris, 1792.

Gregoire, Henri. Rapports et projet de decret presentés à
la Convention nationale au nom du Comité d'instruction publique ...
8 août ... sur la suppression des Académies, Paris, 1793.

Ordre de la marche et des ceremonies qui seront observés
aux funerailles de Michel le Pelletier ..., Paris, 1793.

Ordre et marche de la translation de Volaire a Paris, le
lundi 11 juillet et sa profession de foi, Paris, 1791.

Pajou, Augustin and others. Adresse et projet de status
et règlements pour l'Academie centrale de peinture, sculpture,
gravure et architecture, presentés a l'Assemblée nationale
par la majorité des membres de l'Academie royale de peinture
et sculpture en assemblee deliberante, Paris, 1790.

Proces-verbal de la premiere seance du jury des arts, 17
pluviose an II, Paris, 1794.

Collections, Inventories of Revolutionary Documents and
Visual Materials:

Collection complètte (sic) des portraits de MM. les deputés
a l'Assemblée nationale de 1789, Paris, n.d.

Guiffrey, J.J. Collection des livrets des anciennes expositions
depuis 1673 jusqu'en 1800, Paris, 1869.

Recueil factice de photographies des dessins de Prieur pour
les tableaux historique de la révolution française de
Prudhomme, Paris, 1934.

Un siecle d'histoire de France par l'estampes 1770-1871;
Collection de Vinck; inventaire analytique, ed. by F.L. Bruel,
3 vols., Paris, 1909-1955.

Aesthetics and Salon Criticism:

Amaury-Duval, Charles Alexandre. "Lettres de Polyscope sur les ouvrages exposés dans le grand Salon du Museum," Décade philosophique, vol. VII, no. 54, Paris, 1796.

Batteux, Charles. Les Beaux-arts reduits à un même principe, Paris, 1747.

Caylus, Comte de. Exposition des Ouvrages de l'Académie royale de Peinture, faites dans la salle du Louvre, le 25 aout, 1751, Paris, 1751.

_____. Nouveaux sujets de Peinture et de Sculpture, Paris, 1755.

_____. Parallèle de la Peinture et de la Sculpture, Paris, 1814.

Chaussard, P.J. Essai philosophique sur la dignité des Arts, Paris, 1799.

Diderot, Denis. Oeuvres complètes, 20 vols., Paris, 1876.

_____. Salons, ed. by Jean Seznec and J. Adhemar, 3 vols., Oxford, 1957-.

Dupuy, Leclerc. Mémoire de l'an VI, Paris, 1799.

Emeric-David, T.B. Musée olympique de l'école vivante des Beaux-arts, Paris, 1796.

_____. Recherches sur l'Art statuaire, Paris, 1801.

Guiffrey, J.J. Collections des livrets des anciennes expositions, 42 nos., Paris, 1869-1872.

Mengs, A.R. Oeuvres complètes du chevalier A. R. Mengs, trans. by H. Jansen, 2 vols., Paris, 1786.

Quatremère de Quincy, Antoine-Chrysostome. Considérations sur les arts du dessin en France, suivies d'un plan d'Académie ou d'école publique et d'un système d'encouragements, Paris, 1791

_____. De l'idéal, Paris, 1805.

St.-Yenne, LaFont de. Réflexions sur quelques causes de l'Etat présent de la Peinture en France, Paris, 1747.

_____. Sentiments sur quelques ouvrages de Peinture, Sculpture et Gravure, Paris, 1754.

Winckelmann, J.J. Gedanken über die Nachahmung der griechischen werke in der Malerei und Bildhauerkunst, Dresden, 1755.

Secondary Sources Dealing with Late Eighteenth Century
Aesthetics:

Bagnani, G. "Winckelmann and the Second Renaissance," American
Journal of Archaeology, 59 (1955), pp. 107-118.

Belaval, Yvon. L'esthétique sans paradoxe de Diderot, Paris,
1950.

Benoit, F. L'Art français sous la Révolution et l'Empire, Paris,
1892.

Bertrand, L. La fin du classicisme et la retour à l'Antique dans
la deuxieme moitié du XVIIIe siècle, Paris, 1898.

Fontaine, Andre. Les Doctrines d'Art en France de Poussin à
Diderot, Paris, 1909.

Hatzfeld, Helmut. "J.J. Winckelmann," Journal of Aesthetics and
Art Criticism, VI (Sept., 1947)pp. 1-20.

Hautecoeur, Louis. Rome et la Renaissance de l'Antiquité à la
fin du XVIIIe siecle, Paris, 1912.

_____. Littérature et peinture en France du XVIIIe
au XIXe siecle, Paris, 1942.

Krakeur, Lester. "Aspects of Diderot's Aesthetic Theory," Romanic
Review, XXX,(1938), pp. 244-259.

Lontet de Monval, A. "Diderot et la notion du Style," Revue d'His-
toire litteraire, LI (1951), pp. 288-305.

May, Gita. Diderot et Baudelaire, Critiques d'Art, Paris, 1957.

Rocques, Mario. "L'Art et l'Encyclopédie," Annales de l'Université
de Paris,Numero special no. 1 (October, 1952).

Rocheblave, Samuel. Essai sur le Comte de Caylus, Paris; l'homme,
l'artiste,l'antiquaire, Paris, 1889.

Schneider, Rene. Quatremère de Quincy et son intervention dans les
arts 1788-1830, Paris, 1910.

Seznec, Jean. Essais sur Diderot et l'Antiquité, Oxford, 1957.

Venturi, Lionello. "Doctrines d'Art au debut du XIXe siecle,"
Renaissance, vol. I,(1943), pp. 559-572.

General Background of Late Eighteenth Century Painting:

Bardon, Henry. "Les Peintures a sujets antiques au XVIIIe siècle d'après les livrets de salons," Gazette des Beaux-Arts, 61 (1964), pp. 218-249.

Dorbec, Prosper. "La Peinture francaise de 1750 à 1820," Gazette des Beaux-Arts, (1914), pp. 68-85.

Goncourt, E. and J. de. L'Art du XVIIIe siècle, 3 vols., Paris, 1880.

Locquin, Jean. La Peinture d'Histoire en France de 1747 à 1785, Paris, 1912.

Réau, Louis. "La Peinture francaise de 1785 à 1848," Histoire de l'Art, vol. VIII, pt. 1, Paris, 1925.

Schneider, Rene. L'Art francais du XVIII siècle, Paris, 1926.

The Royal Academy of Painting and Sculpture:

Courajod, Louis. L'Ecole royale des élèves protegées, précedé d'une étude sur le caractère de l'enseignement de l'Art, Paris, 1874.

Paroy, Jean Phillipe. Précis historique de l'origine de L'Académie royale de peinture, sculpture et gravure, Paris, 1816.

General Works on the Revolution and the Fine Arts:

Blondel, Spire. L'art pendant la Révolution, Paris, 1887.

Brown, Milton W. The Painting of the French Revolution, New York, 1938.

Dommanget, Maurice. Le symbolisme et le proselytisme révolutionnaire, Beauvais, 1932.

Dreyfous, Maurice. Les arts et les artistes pendant la période révolutionnaire, Paris, 1863.

Goncourt E. and J. Histoire de la société pendant la Révolution, Paris, 1854.

Renouvier, Jules. Histoire de l'art pendant la Révolution, Paris, 1863.

Venturi, Lionello. "L'art révolutionnaire," Cahiers d'histoire de la Révolution française, I, New York, 1946.

Art and Politics During the Revolution:

Dowd, David. L. Pageant Master of the Revolution, Lincoln, 1948.

_____. "Jacobinism and the Fine Arts: The Revolutionary Careers of Bouquier, Sergent and David," Art Quarterly, XVI, no. 3 (1953), pp. 195-214.

Idzerda, Stanley J. Art and the French State during the French Revolution 1789-1795(unpublished doctoral dissertation), Western Reserve University, 1952.

_____. "Iconoclasm during the French Revolution," American Historical Review, vol. LX (1954), pp. 13-26.

Lapauze, Henri. "Une Académie des Beaux-Arts révolutionnaires,1790-95," Revue des Deux Mondes, XVIII,(December, 1903), 890.

Caubisens-Lasforgues, Collette. "Le salon de Peinture pendant la Révolution," Annales historiques de la Révolution française, n.s.33, no. 164 (Avril, 1961), pp. 191-214.

Leith, James. The Idea of Art as Propaganda in France 1750-1799, Toronto, 1965.

Festivals and Funerals as Aspects of the Revolutionary Religion:

Blum, André. "Les fêtes républicaines et la tradition révolutionnaire," Révolution Française, LXXII (1919), 193-209.

Dunn, S.B. The National Festival in the French Revolution (unpublished Ph.D. dissertation), Cornell, 1939.

Dupre, H. "Some French Revolutionary Propaganda Techniques," The Historian, II (Spring, 1940), pp. 156-159.

Rockwood, Robert O. The Cult of Voltaire to 1791, Chicago, 1935.

Tiersot, Julien. Les fêtes et les chansons de la Révolution, Paris, 1908.

Graphic Art in the Revolutionary Period:

Adhémar, Jean. La gravure originale au XVIIIe siècle, Paris, 1963.

Blum, André. L'estampe satirique et la caricature en France au XVIIIe siècle, Paris, 1910.

_____. La caricature révolutionnaire, Paris, 1916.

Bruand, Yves. La gravure originale en France au XVIIIe siècle, Paris, 1960.

Courboin, Francois. L'estampe francaise au XVIIIe siècle, Brussels, 1914.

Dacier, Emile. La gravure de genre et de moeurs, Paris, 1925.

Henderson, Ernest. Symbol and Satire in the French Revolution, New York, 1912.

Levallée, Pierre. Les Dessins francais de XVIIIe siecle à l'Ecole des Beaux-Arts, Paris, 1928.

Reau, Louis. La gravure d'illustration, Paris, 1928.

Scheyer, Ernst. "French Drawings of the Great Revolution and the Napoleonic Era," Art Quarterly, IV (1941), pp. 187-204.

The Pantheon Project:

Chennevieres -Pointel, P. "Les décorations du Panthéon," L'Artiste, Paris, 1885.

Le Breton, Joachim. Rapport à l'Empereur et Roi sur les Beaux-Arts depuis vingt dernières années, Paris, 1808.

Monval, Jean. Le Panthéon, Paris, 1951.

Quatremère de Quincy, Antoine-Chrysostôme. Rapport sur l'édifice dit de Sainte-Geneviève fait au Directoire du département de Paris, Paris, 1791.

Biographical Data:

Benézit, E. Dictionnaire critique et documentaire des peintres, sculpteurs, dessinateurs et graveurs de tous les temps et tous les pays, 3 vols., Paris, 1911.

Jal, A. Dictionnaire critique de biographie et d'histoire, Paris, 1867.

Peloux, Charles du. Répertoire biographique des artistes du XVIIIe siècle, francais, Paris, 1930.

Works on David:

Cantinelli, R. Jacques Louis David, Paris, 1939.

Chaussard, P.J. Notice sur la vie et les ouvrages de M. J.-L. David, Paris, 1827.

David, Jules. Le Peintre Louis David, Paris, 1867.

Delécluze, E.J. Louis David, son école et son temps; souvenirs, Paris, 1855.

Friedlaender, W.J. David to Delacroix, Cambridge, 1952.

Hautecoeur, Louis. Louis David, Paris, 1954.

Holma, Klaus. David, son évolution et son style, Paris, 1940.

Lindsay, Jack. Death of a Hero, London, 1959.

Miette de Villars, Comte de. Mémoires de David, Paris, 1850.

Saunier, Charles. "Louis David," Les Grands Artistes, Paris, 1928.

Thome de Gamond, A. Vie de David, Brussels, 1826.

Valentiner, W.R. Jacques Louis David and the French Revolution, New York, 1929.

Works on Other Artists:

Debucourt

Fenaille, M. L'oeuvre gravé de Debucourt, Paris, 1899.

Girodet

Levitine, George. Essay on Iconography: Girodet de Trioson (unpublished Ph.D. dissertation) Harvard University, 1949.

Greuze

Hautecoeur, Louis. Greuze, Paris, 1913.

Moreau, le jeune

Maherault, M.-J.-F. L'oeuvre de Moreau le jeune, Paris, 1880.

Guiffrey, Jean. L'oeuvre de P.-P. Prud'hon, Paris, 1924.

Vien

Roy, E. Vien et son temps, Paris, 1886.

Philosophic Art in the Nineteenth Century:

Sloane, Joseph C. "Baudelaire, Chenevard and Philosophic Art," Journal of Aesthetics and Art Criticism, XIII (1955), pp. 285-299.

_____. Paul Marc Joseph Chenevard, Chapel Hill, 1962.

Romanticism in Late Eighteenth Century Art and Literature:

Antal, Friedrich. "Reflections on Classicism and Romanticism," Burlington Magazine, 77 (1940), pp. 72-80.

Babbitt, I. Rousseau and Romanticism, New York, 1919.

Folkierski, Wladyslaw. Entre le classicisme et le romantisme; étude sur l'esthetique et les estheticiens du XVIIIe siècle, Cracow, 1925.

Gombrich, E. "Imagery and Art in the Romantic Period," Burlington Magazine, XCI (June, 1949), pp. 153-164.

Monglond, Andre. Le préromantisme francais, 2 vols., Grenoble, 1930.

Mornet, Daniel. Le sentiment de la Nature de Rousseau à Bernardin de St.-Pierre, Paris, 1907.

Praz, Mario. The Romantic Agony, New York, 1956.

Schinz, Albert. "Le mouvement Rousseauiste du dernier quart de siècle: Essai de Bibliographie critique," Modern Philology, 31, (November, 1922), pp. 149-173.

Viatte, Auguste. Les sources occultes du Romantisme, 2 vols., Paris, 1928.

General History of the Revolution:

Aulard, F.A. The French Revolution: A Political History,
4 vols., London, 1910.

Caron, Pierre. Manuel pratique pour l'étude de la Révolution
française, Paris, 1940.

Gershoy, Leo. The French Revolution and Napoleon, New York,
1933.

Lefebvre, G. and Sagnac, P. La Révolution française, Paris,
1930.

Michelet, Jules. Histoire de la Révolution française, 7 vols.,
Paris, 1847-1853.

Thompson, J.M. Notes on the French Revolution as a Special Subject
in the Honors School of Modern History, Oxford, 1947.

Tocqueville, Alexis de. L'ancien Régime et la Révolution, Paris,
1856.

The Enlightenment and the Idea of Progress:

Becker, Carl. The Heavenly City of the Eighteenth Century
Philosophers, New Haven, 1932.

Bury, J.B. The Idea of Progress, London, 1920.

Cassirer, Ernst. Philosophy of the Enlightenment, New York, 1955.

Cochin, A. Les sociétés de pensée et la Révolution, 2 vols., Paris,
1926.

Frankel, Charles. The Faith of Reason: The Idea of Progress in
the French Enlightenment, New York, 1948.

Green, F.C. Rousseau and the Idea of Progress, Oxford, 1950.

Hazard, Paul. La Pensée européenne au XVIIIe siècle de Montesquieu
à Lessing, Paris, 1946.

Mornet, Daniel. Histoire de la Clarté française, ses Origines, son
Evolution, sa Valeur, Paris, 1929.

_____. Les Origines intellectuelles de la Révolution
française 1715-1787, Paris, 1938.

The Revolution and Religion:

Aulard, F.A. Le culte de la Raison et culte de l'Etre suprême 1793-93, Paris, 1892.

_____. Christianity and the French Revolution, Boston, 1927.

Barker, J.E. Diderot's Treatment of the Christian Religion in the Encyclopedia, London, 1946.

Jarvis, W. Henley. The Gallican Church and the Revolution, London, 1882.

Mathiez, Albert. Les Origines de cultes révolutionnaires, 1789-1792, Paris, 1904.

_____. Contributions a l'histoire religieuse de la Révolution francaise, Paris, 1907.

_____. La Révolution et l'Eglise: Etudes critiques et documentaires, Paris, 1910.

_____. "Robespierre et le culte de l'Etre Suprême," Annales Révolutionnaires, vol. III, Paris, 1910.

Palmer, Robert. Catholics and Unbelievers in 18th century France, Princeton, 1939.

Parker, Harold T. The Cult of Antiquity, Chicago, 1937.

The Revolutionary Spirit in Nineteenth Century Philosophy:

Ballanche, Pierre-Simon. Essai de Palingenésie social, 2 vols., Paris, 1827-1829.

Fantin-Desodoarde, Antoine Etienne. Histoire philosophique de la Révolution, 6 vols., Paris, 1817.

Elton, G. The Revolutionary Idea in France 1789-1871, London, 1927.

Gouffroi, Theodore. Mélanges philosophiques, 2 vols., Paris, 1833.

Michelet, Jules. Histoire de la Révolution française, 7 vols., Paris, 1847-1853.

Quinet, Edgar. Oeuvres completes, 10 vols., Paris, 1857.

ILLUSTRATIONS TO THE TEXT

Plates III, IX and X, XXXV and XXXVIII do not appear in the list
since they proved to be unavailable.

PLATE I Oath of the Horatii by J.L. David (Louvre)

PLATE II Death of Socrates by J.L. David (Metropolitan Museum of Art)

PLATE IV The Punished Son by J.B. Greuze (Louvre)

PLATE V Antiochus and Stratonice by J.L. David (Ecole des Beaux Arts,
 Paris)

PLATE VI Belisarius by J.L. David (Musée des Beaux Arts, Lille)

PLATE VII Andromache Mourning over the Body of Hector by J.L. David
 (Ecole des Beaux Arts, Paris)

PLATE VIII Paris and Helen by J.L. David (Louvre)

PLATE XI Brutus and the Lictors Bearing the Bodies of His Sons by
 J.L. David (Louvre)

PLATE XII Engraving of the Festival of Unity and Indivisibility,
 August 10, 1792 (Bibliothèque Nationale, Cabinet des Estampes)

PLATE XIII Anonymous anti-clerical cartoon, The Religion of Our Fathers
 (Musée Carnavalet)

PLATE XIV Anonymous anti-clerical cartoon, Who Laughs on Friday Will
 Cry on Sunday (Photo from Ernest Henderson, Symbol and
 Satire in the French Revolution (New York, 1912)

PLATE XV Anonymous anti-clerical cartoon, The Patriotic Reducer of
 the Flesh (Photo: Henderson)

PLATE XVI Revised Republican Calender (Musée Carnavalet)

PLATE XVII Anonymous engraving of the Festival of the Federation,
 July 14, 1790 (Musée Carnavalet)

PLATE XVIII Anonymous Dutch engraving of the Festival of the Federation
 (Photo: Henderson)

PLATE XIX Anonymous engraving of the "Fountain of Regeneration" from
 the Festival of Unity and Indivisibility (Photo: Henderson)

PLATE XX Anonymous engraving of a portion of the design for a relief
 on the temporary arch in the Festival of Unity and Indivisi-
 bility (Photo: Henderson)

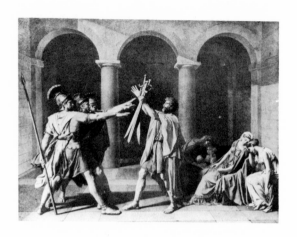

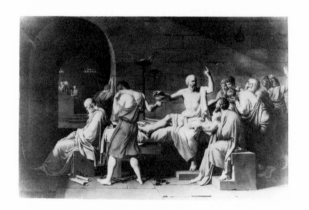

Pl. I (top); Pl. II (bottom)

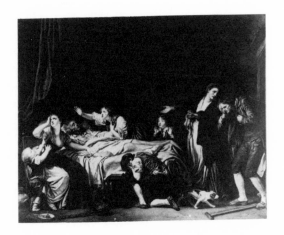

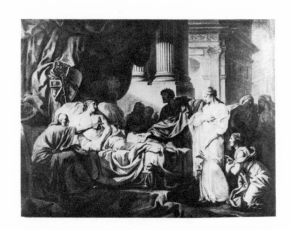

Pl. IV (top); Pl. V (bottom)

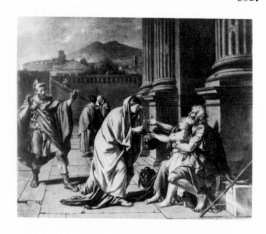

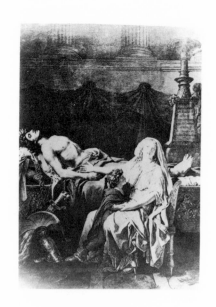

Pl. VI (top)
Pl. VII (bottom)

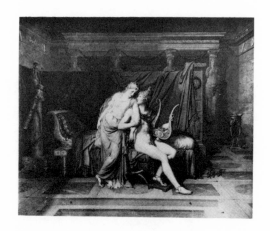

Pl. VIII

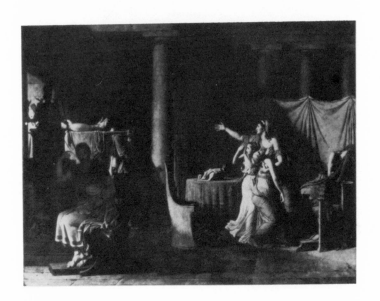

Pl. XI

Pl. XII

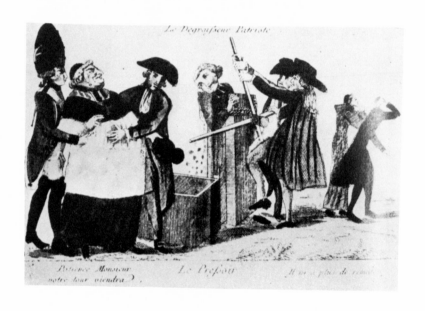

Pl. XIII (top); Pl. XIV (bottom)

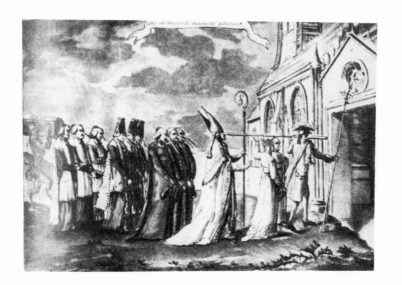

Pl. XV

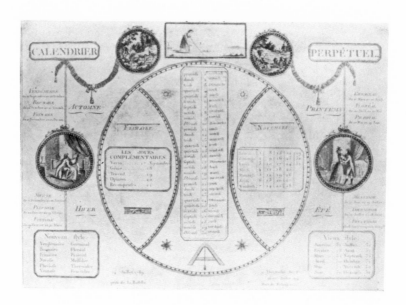

Pl. XVI

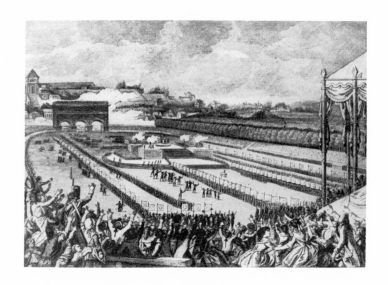

Pl. XVII (top)
Pl. XVIII (bottom)

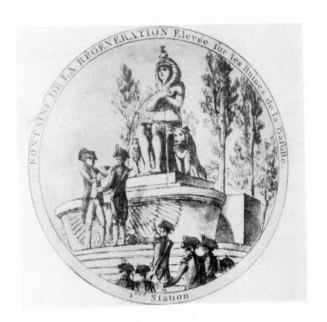

Pl. XIX

Pl. XX

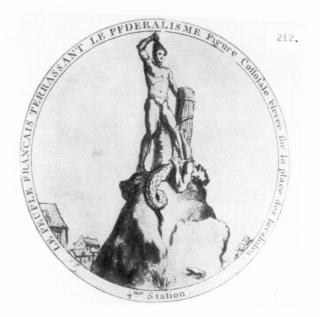

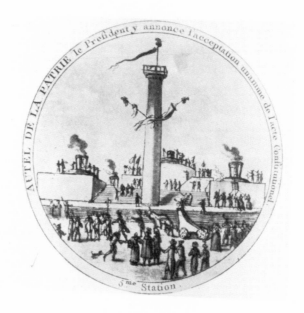

Pl. XXI (top)
Pl. XXII (bottom)

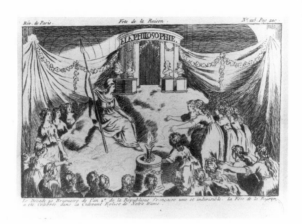

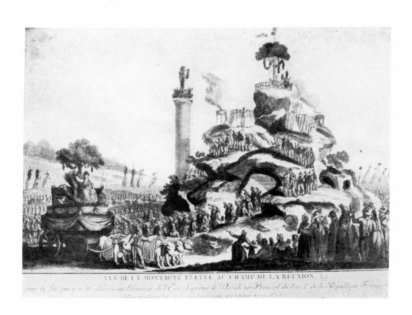

Pl. XXIII (top); Pl. XXIV (bottom)

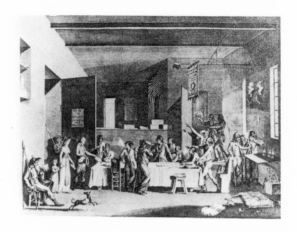

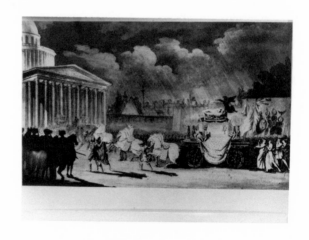

Pl. XXV (top)
Pl. XXVI (bottom)

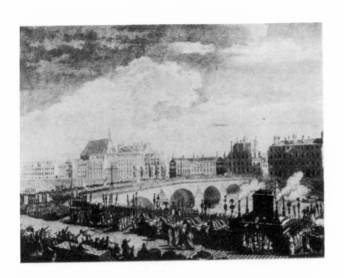

Pl. XXVII

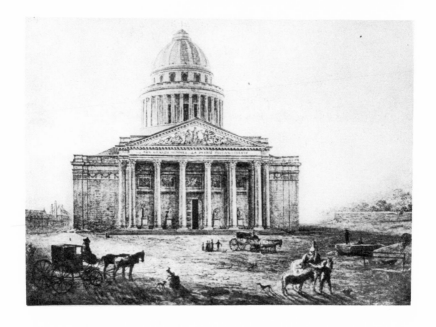

Pl. XXVIII (top)
Pl. XXIX (bottom)

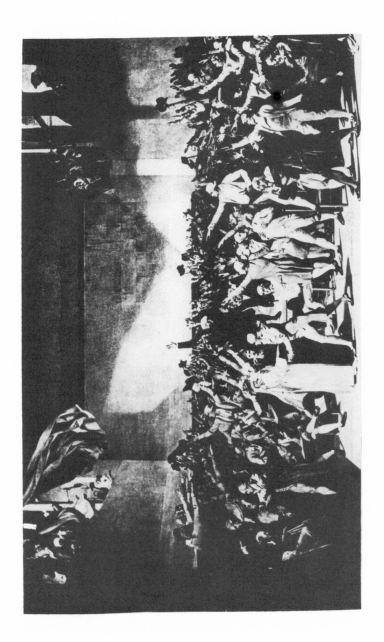

Pl. XXX

Pl. XXXI

pl. XXXII

Pl. XXXIII

Pl. XXXIV

Pl. XXXVI (top)
Pl. XXXVII (bottom)

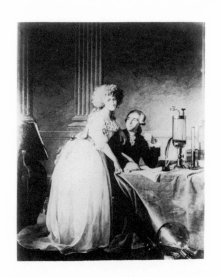

Pl. XXXIX (top)
Pl. XL (bottom)

Pl. XXIXa

Pl. XLI

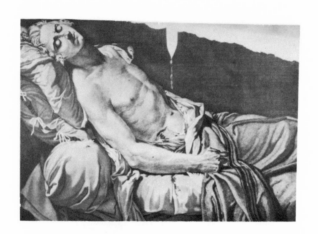

Pl. XLII

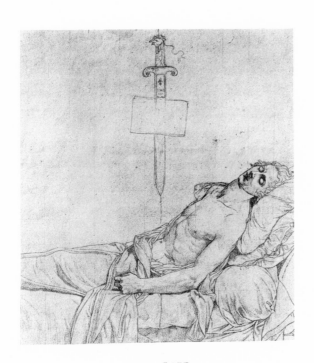

Pl. XLIII

Pl. XLIV

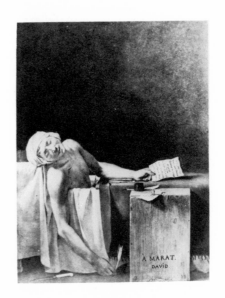

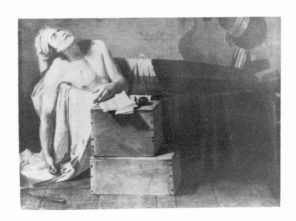

Pl. XLV (top)
Pl. XLVI (bottom)

Musee Carnavalet- MARAT (Bulloz phot)

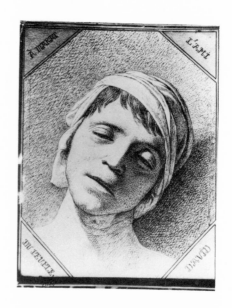

PL. XLVII (top)
Pl. XLVIII (bottom)

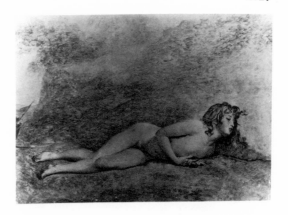

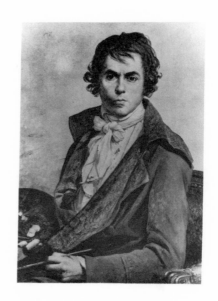

Pl. XLIX (top)
Pl. L (bottom)

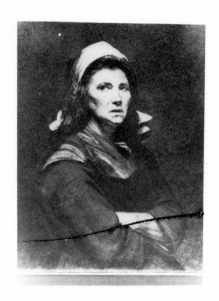

Pl. LI (top); Pl. LII (bottom)

Pl. LIII

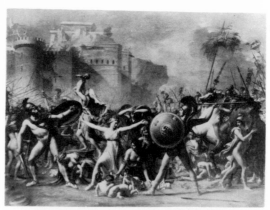

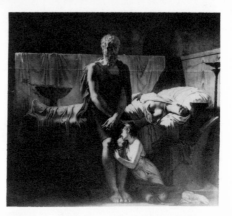

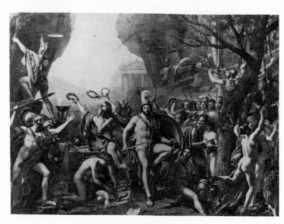

Pl. LIV (top)
Pl. LV (center)
Pl. LVI (bottom)

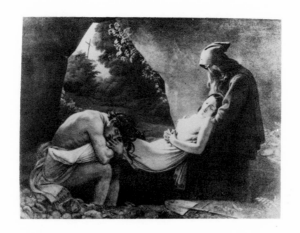

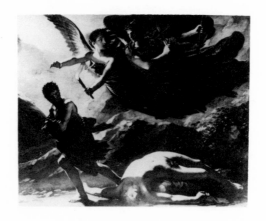

Pl. LVII (top)
Pl. LVIII (bottom)

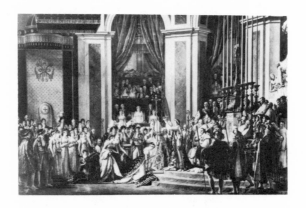

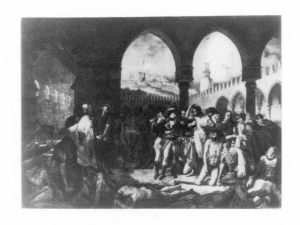

Pl. LVIX (top)
Pl. LX (bottom)

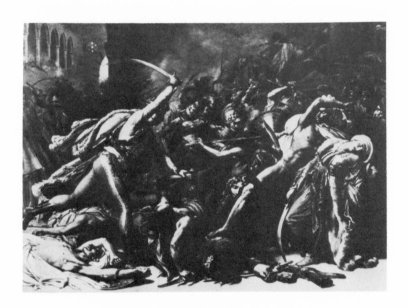

Pl. LXI